Vincent Van Gogh
Masterpieces of Art

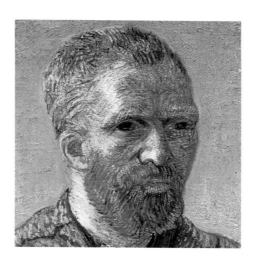

Stephanie Cotela Tanner

FLAME TREE
PUBLISHING

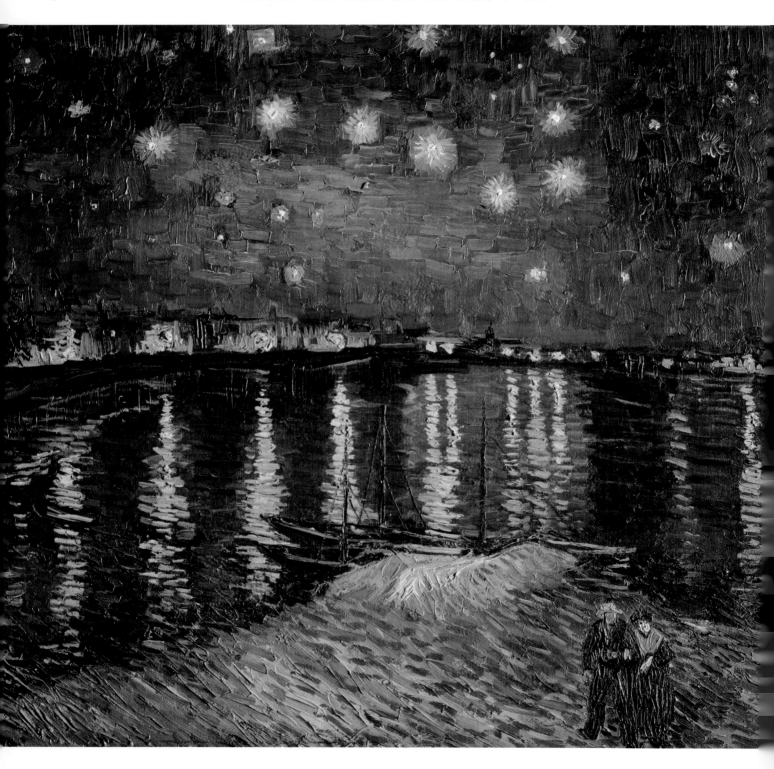

Contents

Van Gogh: Master of Colour
6

The Netherlands and Paris
34

Arles
50

Saint-Rémy
86

Auvers
108

Index of Works
126

General Index
127

Vincent Van Gogh: Master of Colour

A legendary artist, Vincent Van Gogh's (1853–90) brilliantly creative oeuvre is inextricably linked to his reputation as a mad genius. Similarly to today's celebrities, it is impossible to separate Van Gogh's troubled life from his works of art. Arguably, he created his most powerful masterpieces while enduring his most extreme battles with psychosis. His desire to keep his illness at bay resulted in a frenetic outpouring of one work after another, sometimes driving him to complete a painting in a single day.

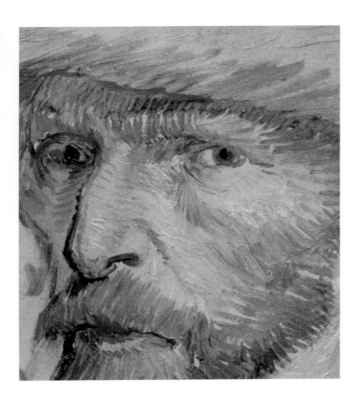

LIFE

Anecdotal accounts of the artist's life – his tumultuous relationship with colleague Paul Gauguin (1848–1903), swallowing a tube of paint as a means of 'tasting the colour yellow', repeated bouts of insanity for which he was hospitalized, the most infamous tale of slicing off a piece of his ear – all serve to mythologize the man before we even start to analyze his works of art.

Early Years

Van Gogh's early experiences consisted of a string of varied career ventures, all of which were unsuccessful. Before finding his way as an artist, he tried his hand at being an art dealer, teacher and even embarked on life as a preacher. It might seem as if these ventures were dead ends, but these early explorations all contributed to shaping Van Gogh as the inspirational artist he was eventually to become.

Born in the Netherlands in the town of Groot Zundert, North Brabant, close to the Belgian border, Van Gogh's childhood was devoutly religious. He was the eldest of six children and it was his younger brother, Theo (1857–91), born four years after Vincent, who would become his confidant and eventually his benefactor throughout his life. His father Theodorus was a Dutch Reformed minister, thus religion remained a central theme throughout his life and a subtle undercurrent in his art.

Following his father's advice, at the age of 16 Van Gogh began a brief career as an art dealer. It was his uncle, an affluent art dealer himself,

who facilitated his employment at the French-owned Goupil & Cie gallery in The Hague. The gallery specialized in French contemporary art and sold prints and photographic reproductions of Salon favourites.

Theo also embarked on a career as an art dealer, joining Goupil & Cie's Brussels branch in 1873, a role in which he remained for the rest of his life and which would complement his brother's artistic ventures.

Van Gogh's experience as an art dealer enriched his knowledge of art history and exposed him to international art trends. He maintained scrapbooks of Dutch and French reproductions, which would ultimately shape his style and technique as an artist. In addition to the visual arts, he also explored French and English literature. Authors who addressed the human condition, such as Émile Zola, were of the most interest.

A Change of Direction

In 1876 Van Gogh began to lose interest in the art trade business. His career as an art dealer came to an acrimonious end and he was forced to resign due to a change in character brought on by a sudden religious fanaticism. He subsequently held roles as a teacher in London and as a clerk in a bookstore in Dordrecht, before dedicating his life to the Church.

In May 1877, following in his father's footsteps, he became a student of theology and later a lay minister. As the formal education was not to his liking, Van Gogh avoided university and instead opted for a three-month missionary training course in Brussels. The role of a missionary suited him, as he was more interested in the plight of the common man and helping those less fortunate than he was in adhering to the stringent protocols of church rhetoric. In his role as a missionary, he was sent to the Borinage, a coal-mining district in south Belgium, in November 1878. The Borinage was an impoverished town and the experience awakened Van Gogh's compassionate side and opened his eyes to the harsh realities of the underprivileged, which contrasted greatly with his bourgeois upbringing.

His skills as a nurse were especially commended, as were his notable acts of kindness. For example, he allegedly gave away clothes and

other possessions to those in need. He even went so far as to live amongst the poor, which led to the dismissal from his post as a lay preacher, as his superiors felt that his actions were inappropriate and not in accordance with his duties. Although this role did not prove to be Van Gogh's calling, as an artist he incorporated themes inspired by his experiences into his paintings, such as images of hard-working peasants with work-worn hands.

Becoming an Artist

In the summer of 1880, with encouragement from Theo, Van Gogh began to realize his artistic potential. His earliest works were sketches of working-class people he observed, such as miners.

He was immensely influenced by the French master of the Barbizon School, Jean-François Millet (1814–75), who is renowned for his depictions of peasant life, a theme that was of utmost interest to Van Gogh. The two artists shared a background in Catholicism (Van Gogh had a Catholic teacher), which manifested itself in their compassionate renderings of rural subjects sprinkled with biblical references. Millet's influence became a mainstay throughout Van Gogh's career. He dutifully paid homage to the traditions of Dutch art, which was often representational of everyday life and 'salt of the earth' individuals.

The first artistic group from which he drew inspiration and with whom he would eventually work was the Hague School. Artists of the school looked to the Dutch Golden Age of the seventeenth century as a source of inspiration. Other Dutch artists, such as Jozef Israëls (1824–1911) – often compared to Millet for his commitment to Realism – and prolific draughtsman Honoré Daumier (1808–79), also caught his attention.

Masters such as Rembrandt Harmenszoon van Rijn (1606–69), particularly with regard to his use of chiaroscuro (light and shading), and Johannes Vermeer (1632–75), mostly for his use of colour, shaped Van Gogh's art as far as traditional subject matter, style and technique were concerned.

Mimicking the Masters

Van Gogh copied the work of the Old Masters and often returned to their historical subjects. For example, in Saint-Rémy in 1889, he painted *Half Figure of an Angel (after Rembrandt)* (*see* page 89), in which he depicted an angel with downcast eyes, swathed in a glowing light and floating amongst a deep blue sky. The compositional style and illusory background are typically Van Gogh but the angel's face, half-hidden by a shadow, is painted with the realistic precision inspired by Rembrandt.

From the start, Van Gogh strove to depict the world around him accurately, in an uncomplicated and straightforward manner, in order to convey the real nature of the subject or object that he was painting. His early works combine an astute observation filtered by his emotions. Landscapes by Hague School artists Jacob Maris (1837–99) and Johan Hendrik Weissenbruch (1824–1903), whom he encountered during his employment at Goupil, became a source of inspiration for his Realist approach.

Johannes Vermeer was his greatest early influence in terms of colour. Van Gogh was captivated by the techniques he employed to represent light and shadow by juxtaposing saturated blocks of colour. In 1888 he wrote to fellow artist Émile Bernard (1868–1941), 'It is true that in the few pictures he [Vermeer] painted, one can find the entire scale of colours; but the use of lemon yellow, pale blue and light grey together is as characteristic of him as the harmony of black, white, grey and pink is of Velázquez.'

Van Gogh drew upon a wide range of sources, including engravings and illustrated magazines that he encountered while in London. In some cases, it would take a while for these influences to manifest themselves in his work.

In a letter to Van Rappard in September 1882, he wrote, 'More than 10 years ago, when I was in London, I used to go every week to the show windows of the *Graphic* and the *Illustrated London News* to see the new issues. The impressions I got on the spot were so strong that, notwithstanding all that has happened to me since, the drawings are clear in my mind My enthusiasm for those things is rather stronger than it was even then.'

Van Gogh's Letters

In addition to his artistic output and fascinatingly tragic life, Van Gogh's letters, the bulk of which were written to his brother Theo, have been the centre of many recent exhibitions and publications. They have captivated audiences and assisted scholars in understanding and contextualizing his art.

The writing began with a letter to Theo in 1872 and from that point on Van Gogh kept up a steady flow of correspondence in French, English and Dutch. Though Theo was his leading correspondent, Van Gogh also wrote letters to his other siblings and fellow artists, including Anthon van Rappard (1858–92), Émile Bernard and Gauguin, deliberating on topics that spanned nature, art, literature and life.

More than a daily account of the artist's life in his own words, Van Gogh's letters often included sketches and interpretations of works, revealed his influences, techniques and materials used, and showed the strength of his religious beliefs. Moreover, the letters reveal a lucid and methodological thought process that is often overshadowed by tales of the artist's maniacal outbursts.

Hundreds of letters written and received by Van Gogh provide a wealth of insight into his unique creative process. As the correspondence reveals, it was Theo whom Van Gogh relied upon and thus was the biggest influence on his artistic decisions. Theo, a prominent art dealer, provided his brother with insider knowledge of the art market as well as steering him towards useful contacts within the art world.

Johanna Van Gogh-Bonger (1862–1925), Theo's wife, compiled the first extensive collection of Van Gogh's letters, consisting of three volumes, which was published in 1914. In 1958 an even more comprehensive collection was published, which was edited by Theo's son, Vincent Willem Van Gogh, and translated into English.

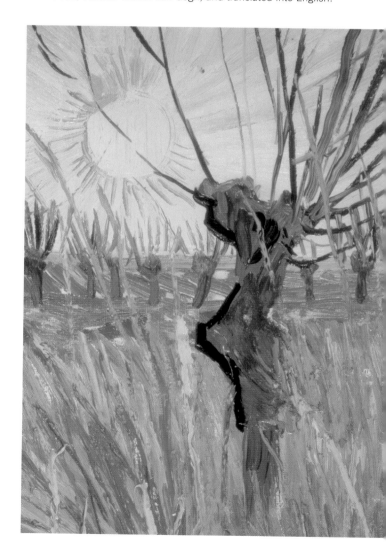

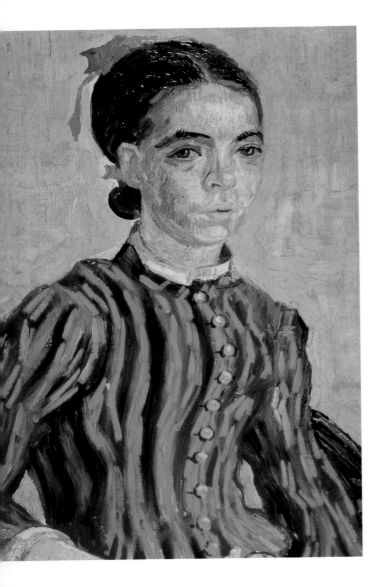

attracted to older women), she was devoutly religious and she was recently widowed, a circumstance in which he had hoped she would need consoling.

True to his obsessive nature, Van Gogh pursued Vos-Stricker relentlessly, much to her dismay. He inundated her with letters, which she subsequently returned unopened, and spontaneously visited her at the home of her parents. It is said that, during one of his visits, he held his hand over a lamp flame and demanded that her parents allow him to see her.

Van Gogh had been refusing to go to church to spite his father, and his career choice as an artist, combined with his outrageous behaviour, caused his parents to ask him to leave the family home. Later that year Van Gogh moved to The Hague, a booming artistic centre. The move was a turning point both personally and artistically. It enabled Van Gogh to live amongst other Dutch artists from whom he would learn the tricks of the trade and it marked his first major step in becoming an artist.

Due to the strained relationship between Van Gogh and his parents, and the loss of their financial and emotional support, he turned to his brother Theo and would do so for the remainder of his life.

Another Doomed Romance

Shortly after arriving in The Hague, Van Gogh began another romantic relationship, this time with Clasina 'Sien' Hoornik, a pregnant prostitute. He quickly invited her and her daughter to live with him. Although it was not a passionate romance, the arrangement proved beneficial for both parties. Artistically, it provided Van Gogh with a model and enabled him to observe the personality of the sort of archetypal, downtrodden individual who often featured in his work. On the other hand, his compassionate and nurturing personality provided Hoornik with care, protection and a chance to better her situation. However, despite the initial advantages, the relationship ended bitterly after just one year.

Throughout his life, Van Gogh pursued several turbulent relationships, mostly fuelled by his intense personality, short temper and, not least,

Difficult Relationships

Romantic relationships were not Van Gogh's strong point. Though he did have brief periods of female companionship, they often ended badly, leaving him profoundly depressed.

In 1881, while living with his parents in Etten, a village in the province of Gelderland, Van Gogh fell in love with his cousin, Kee Vos-Stricker. His attraction to her was threefold: she was older (and he was

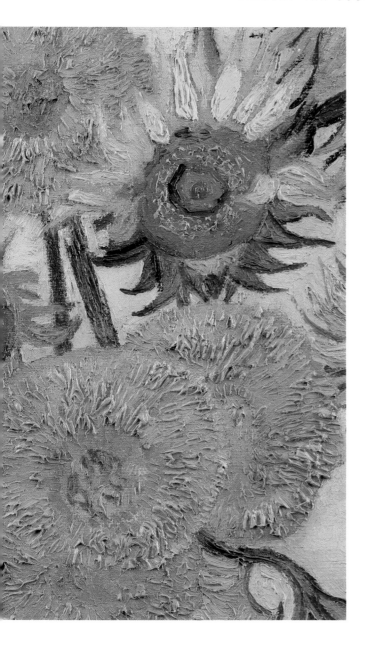

In the beginning the mood was bright and full of possibility. Van Gogh was excited about the prospect of collaborating with another artist and had been trying to persuade Gauguin to join him in Arles for some time before he finally agreed. Filled with anticipation, Van Gogh embarked upon painting 'decorations for the yellow house', including *Sunflowers*: a series of still lifes intended to decorate the studio that the two artists were to share (*see* page 82). Van Gogh chose the sunflower still lifes in an effort to show off his skills as a painter and impress his friend and soon-to-be collaborator, knowing that Gauguin admired them from their days in Paris.

There are several different versions within the *Sunflowers* series: some with blue backgrounds and some with yellow, the latter being the more difficult as Van Gogh had to negotiate varying degrees of yellow in order to set the flowers apart from the rest of the picture. He had to work quickly to capture the flowers at their fullest bloom. He determinedly set out to complete a dozen paintings, but ended up completing only four in time for Gauguin's arrival. He returned to the theme in the autumn of 1889, working from previous canvases as sunflower season had passed.

Stormy Times with Gauguin

Gauguin arrived in October and the two worked together for nine weeks, during which Van Gogh suffered from various types of epilepsy, psychotic attacks and delusions. His 'ravings' inevitably put a strain on their relationship. As tensions grew, Van Gogh's delicate mental state began to deteriorate. During a particularly violent psychotic meltdown, Van Gogh threatened Gauguin with a knife. Evidence of their hostility is also revealed by Gauguin: he painted a portrait of Van Gogh in front of one of his sunflower canvases, which Van Gogh described as 'certainly me, but me gone mad'.

mental instability. Most famous was his conflict with Gauguin, which reached its climax during the time they spent living and working together in Arles from 1888–89. The film *Lust for Life* (1956) directed by Vincente Minnelli, in which Kirk Douglas played the part of Van Gogh and Anthony Quinn the part of Gauguin, immortalized the relationship between the famous artists.

It was during this time that Van Gogh famously cut off a piece of his left ear lobe. The exact reason behind the now legendary act of self-mutilation is not known. It has been suggested that it was the result of a physical altercation with Gauguin or an attempt to win the affection of a prostitute to whom he presented the lobe as a token of his love.

The ear incident landed him in the hospital in Arles for several months. For Van Gogh it seemed that sanity was a small price to pay for fulfilling his greater calling as an artist. For example, in the painting *Self-portrait with Bandaged Ear* (*see* page 81) he is depicted standing in the foreground, his easel propped up in the background and a Japanese print hanging on the wall. He portrays himself not as a victim but as an artist first and foremost.

Upon his release in January 1889, he found it difficult to get back on his feet and resume painting. He maintained that the culprits behind his breakdown were alcohol and tobacco abuse, both of which he continued to indulge in.

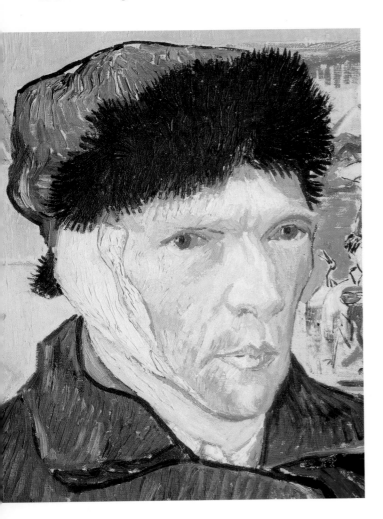

Fearing a relapse, Van Gogh was voluntarily committed to the psychiatric hospital Saint-Paul-de-Mausole at Saint-Rémy, just outside of Arles, in May 1889. In a letter to their mother, Theo wrote, 'Out of his own free will and with the co-operation of Reverend Salles it has now been decided that for some time he will be looked after in Saint-Rémy, not far from Arles, where there is an institution that has 45 patients.'

The peaceful conditions at the hospital, which was surrounded by gardens, enabled Van Gogh to get on with his work and he seemed to appreciate the solitude. In a letter to Theo he wrote, 'I wish to remain shut up as much for my own peace of mind as for other people's.' Physician Dr Théophile Peyron diagnosed the artist with 'acute mania with hallucinations of sight and hearing'.

Exactly what ailed Van Gogh is not known and contemporary medical opinions vary. The most favoured explanation is that he suffered from a form of epilepsy complicated by a bipolar disorder.

A Prolific Painter

Van Gogh spent about a year in Saint-Rémy, during which time he created nearly 150 paintings, all dutifully sent to Theo in Paris in the hopes of a sale. His output, even at the height of his illness, was prolific and he produced works that have since become his most recognized masterpieces, such as *The Starry Night* (*see* page 90), *Wheatfield with Cypresses* (*see* page 102) and *Irises* (*see* page 93).

Drawing heavily from nature, as Van Gogh was not interested in painting his fellow patients, *Irises* was one of the first paintings that he produced while he was in Saint-Rémy. Luckily, the irises were in full bloom at the time, thus enabling the artist to capture each detail in dynamic glory. The vibrant colours bring the flowers to life as they appear to be swaying in the wind along the lines of the artist's long, smooth brushstrokes. The flowers invade the viewer's space, seemingly overflowing from the canvas. The purple irises set against the bold colour planes of orange, green and yellow highlight the individual qualities of each flower, all of which take on their own shape.

Modestly, Van Gogh considered the painting a mere study but Theo immediately recognized it as a masterpiece and later that year he submitted it for exhibition at the Salon des Indépendants in Paris. Theo saw the quality in this and other paintings produced at that time, and in a letter he wrote, 'In all of them there is a vigour in the colours which you had never achieved before … but you have gone further than that, and while some try to attain the symbolic by doing violence to the form, I find it in many of your canvases in the quintessence … of your thoughts on nature and living creatures.'

In the last months of his life, Van Gogh painted several landscapes featuring wheat fields. In a letter to Theo he explained his inspiration and aspiration: 'They depict vast, distended wheat fields under angry skies, and I deliberately tried to express sadness and extreme loneliness in them.' He added, 'I am almost certain that these canvases illustrate what I cannot express in words, that is, how healthy and reassuring I find the countryside.'

His Last Work?

Wheatfield with Crows (*see* page 125) is generally considered to be Van Gogh's last painting, although that is debatable. The vast, desolate field seems bleakly appropriate given the artist's likely mood before his suicide. Van Gogh makes no reference to this painting in any of his letters, which for some strengthens the argument that this was his last work, since he did not write as frequently in the months prior to his death.

The image of the deserted landscape with its violent brushstrokes exemplifies anguish. In this field of overgrown wheat, viewers are confronted by a cloudy sky filled with menacing crows, some of which appear to be hovering, while others are soaring. Perhaps more unsettling still is the abruptly ending road. Though the colours are vibrant – dark blue tones set against yellow and green – there is something unavoidably troubling about this painting, which the specks of black paint that comprise the crows seem to angrily point out.

Another contender for Van Gogh's last painting is *Daubigny's Garden* (*see* page 123), which may be seen as an homage to

Charles-François Daubigny (1817–78), an artist whom he greatly admired. Van Gogh painted his garden several times, concerning himself with the colours of the vibrant landscape. In a letter to Theo he describes the composition: 'In the foreground green and pink grass [...]. In the centre a rose bush, to the right a little gate [...] [and] a row of yellow lindens. The house itself is in the background, pink with a roof of bluish tiles.' The final outcome is beautiful, reflecting soft Impressionistic tones. Pleased with the outcome, Van Gogh declared, 'It is one of my most purposeful canvases.' Beyond the beauty of the painting, scholars speculate that for Van Gogh the enclosed garden represented a sense of unnatural confinement.

A third possibility may be *White House at Night* (*see* page 124). In the last few months of his life, houses became a regular motif for Van Gogh. Representing buildings rather than the wild unpredictability of nature called for a more structured approach, including accurately executed geometric shapes and lines. In *The White House at Night*, the house, separated from the street by a low wall, dominates the canvas. The curious figure in the foreground, clad in dark clothing and carrying a knife, has a somewhat hollow face, resembling the grim reaper. Another disturbing aspect is the red glow emanating from two windows, symbolizing the 'eyes' of the house. Though again beautifully rendered, this image too betrays underlying tensions.

A Tragic End

In the summer of 1890 Van Gogh visited his brother in Paris. During his stay Theo informed him of his decision to set up his own business, which meant that his finances would be limited for some time. He recommended that they both tighten their purse strings.

Van Gogh did not react well to the news as he did not feel that he could sustain his lifestyle without the support of his brother. Despite Theo's precarious position, Van Gogh concentrated more on the effect that this event would have on him. After he returned home, he expressed his disappointment in a letter to Theo: '… but my life too is threatened at its very root, and my step is unsteady too'.

Shortly after, on 27 July 1890, Van Gogh wandered into a wheat field, painting supplies in hand, and shot himself with a revolver just below the heart. He somehow managed to return to his room at the Ravoux Inn in the centre of Auvers-sur-Oise. As he lay bleeding to death, he was discovered and Theo was informed. He immediately rushed to his dying brother's side and Van Gogh died in Theo's arms. Theo, who had fallen ill after his brother's death, joined him six months later. In death, just as in life, the two brothers remain at each other's side at the Notre Dame D'Auvers cemetery in France.

The outpouring of mourners who attended Van Gogh's funeral was a true testament to the effect he had on the art world. Notably, fellow artist Bernard validated Van Gogh's position amongst the art community proving that at his death he had reached the height in his career that he had been striving for throughout this life. In his honour they covered his coffin with yellow flowers and set his easel and brushes alongside his casket.

Immediately after Van Gogh's death, Theo held a memorial exhibition in his Paris apartment, and loyal friend and lifetime correspondent Bernard was proactive in attracting attention to Van Gogh's outstanding accomplishments. He wrote about him, organized the first solo exhibition of his works in Paris and published a book of their letters. The original letters are now part of the collection at The Morgan Library & Museum in New York. Days after Van Gogh's burial, Bernard wrote to

art critic Albert Aurier (1865–92), 'His funeral was an apotheosis, certainly worthy of his great spirit and great talent.' The Salon des Indépendants of 1891 paid homage to Van Gogh by displaying a group of his works, which one critic described as 'being in the presence of someone loftier, more masterly, a person who disturbs me, moves me, commands attention'.

Commercial Success

The critic's reaction to the Salon show was just the beginning of Van Gogh mania. Many years later, in 1962, upon the bequest of his nephew, The Vincent Van Gogh Foundation was established. In 1973 the Van Gogh Museum opened. Today his most famous images are endlessly reproduced as prints and calendars, and on everything from clothing to umbrellas.

His paintings are ranked amongst the highest-priced works sold at auctions or private sales. In 1987, *Still Life: Vase with Fifteen Sunflowers* (*see* page 82) sold for $39.9 million at Christie's in London. Later that year, *Irises* (*see* page 93) achieved a record-breaking $53.9 million at Sotheby's in London. The buyer subsequently sold the painting to the J. Paul Getty Museum in Los Angeles, California, where it hangs today.

Van Gogh died at the age of 37. His short life was filled with anguish and struggle, both professional and personal. He sacrificed his own wellbeing and relationships with others in an effort to achieve greatness. For instance, when funds were low, he would spend his money on paint supplies rather than food.

He was weighed down with the constant worry of selling his work, which accounts for the rate at which he produced painting after painting. He was obsessed with his progression as an artist and often placed himself in difficult situations as a means to reach his goal. Compounding his anxiety were feelings of displacement, which were most pronounced during his time in Paris. In a letter to a friend and colleague, he wrote, 'What is to be gained is progress and, what the deuce, that it is to be found here I dare ascertain. Anyone who has a solid position elsewhere let him stay where he is but for adventurers as

myself I think they lose nothing in risking more. Especially as in my case I am not an adventurer by choice but by fate and feeling nowhere so much myself a stranger as in my family and country.'

Though his career was brief, it was highly productive, resulting in more than 2,000 paintings within a 10-year period. Sadly, he sold very few paintings in his lifetime and did not live long enough to see the iconic

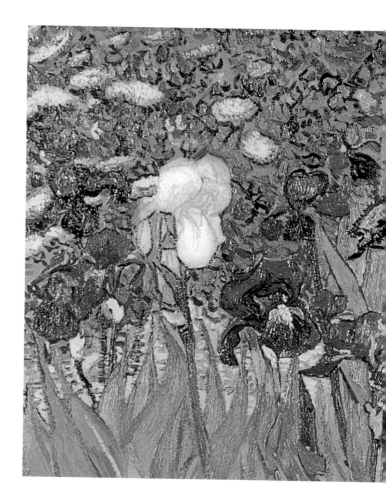

status to which he rose. Though he was financially dependent, mentally unstable and lonely for much of his life, his laborious commitment to his craft never waned. His work, despite the speed at which it was produced, was executed with a calm precision that demands contemplation.

SOCIETY

The nineteenth century was a period of enormous change, in great part sparked by the Industrial Revolution that affected technological advances, the socio-economic climate throughout Europe and cultural stabilities. There was a distinct class division: the middle classes had grown and were becoming wealthier, while the lower classes were crammed together in primitive living conditions. Labourers and peasants were drawn to the city. Van Gogh, who was from a bourgeois family, found himself increasingly critical of the background in which he had been raised.

Education

Though he did have brief intervals during which he engaged in formal education, it was not in Van Gogh's nature to follow academic protocol. He was largely a self-taught artist. However, he did undergo training throughout various points in his career.

Anton Mauve (1838–88), Van Gogh's cousin by marriage and a leading member of the Hague School, was of utmost importance to Van Gogh's early training. Mauve encouraged his drawing and pushed him to start experimenting with watercolour and oil techniques. Van Gogh produced many still lifes under Mauve's tutelage. Honing his skills, he progressed from representing the world around him to copying the works by renowned masters – specifically, Millet. However, his greatest source of inspiration was nature.

Interested in mastering his skills as a figure painter following the failure of *The Potato Eaters* (*see* page 37) in 1885, Van Gogh enrolled in the art academy in Antwerp to further his technical training. It was there that he discovered Japanese prints and the work of Flemish master Peter Paul Rubens (1577–1640), which would thereafter influence his style. During his three months at the academy, he experimented with portraits, seeking out café workers to be his models, and concentrated on trying to capture their individual character. Though his time at the academy was brief, he was happy with his progress, which in turn strengthened his confidence as a painter.

He befriended classmate Horace Mann Livens (1862–1936), an English painter who is credited with painting the earliest portrait of Van Gogh. The two kept up correspondence while Van Gogh was in Paris. In particular, Van Gogh was attracted to Livens's use of colour and the connections that he made between art and literature. He wrote to Livens about painterly techniques, invited him to Paris and hinted at a collaboration based on their similar tastes in the use of vibrant colour.

In 1886 he wrote to Livens, 'If I knew you had longings for the same we might combine. I felt sure at the time that you are a thorough colourist and since I saw the Impressionists I assure you that neither your colour nor mine as it is developing itself is exactly the same as their theories but so much dare I say, we have a chance, and a good one, of finding friends.'

École des Beaux-Arts

Later, in Paris, Van Gogh had the opportunity to make several influential acquaintances, thanks to his art-dealing brother Theo. Once

again he embarked on formal training at the *École des Beaux-Arts* in Paris, which placed him in the studio of academy artist Fernand Cormon (1845–1924).

Cormon's approach was traditional, which Van Gogh found to be too conservative for his tastes. Of his experience he wrote to Livens, 'I have been in Cormon's studio for three or four months but did not find that so useful as I had expected it to be. It may be my fault however, any how I left there too as I left Antwerp and since I worked alone, and fancy that since I feel my own self more.'

He also felt out of place due to the fact that his tastes and vision were very different from his classmates'. For these reasons, his lessons were not successful. However, the time he spent at Cormon's studio exposed him to the work of the Impressionists and he benefited from the invaluable contacts that he made there, such as Henri de Toulouse-Lautrec (1864–1901) and Émile Bernard, who in turn were responsible for introducing Van Gogh to Gauguin, and the Neo-Impressionists Paul Signac (1863–1935) and Georges Seurat (1859–91).

Subject Matter

From his rural upbringings, Van Gogh was always interested in subjects involving the act and effects of labour. He became a leading 'peasant' painter due to his numerous depictions of working-class people.

His most ambitious 'peasant' painting is *The Potato Eaters*, now considered his earliest masterpiece, which he completed in 1885 while living in the countryside around Nuenen.

Van Gogh invested months preparing for the final work, producing numerous studies to ensure that his figures were anatomically accurate. Working from his preparatory drawings, he set out to create an elaborate painting that would impress the art world. In a letter to Theo he revealed, 'I want to make it clear how these people, eating their potatoes in the lamplight, have dug the earth with the very hands they put in the dish, and so it speaks of manual labour and how they have honestly earned their food.'

The Potato Eaters is a visual depiction of the labour that goes into a simple meal. Rendered with a dark, sombre palette, the scene shows a group of peasants gathered around the table in the foreground of a dim, cluttered space. Each figure bears signs of the effort that went into preparing the family meal: the sowing and pulling, the scrubbing and cooking of the potatoes.

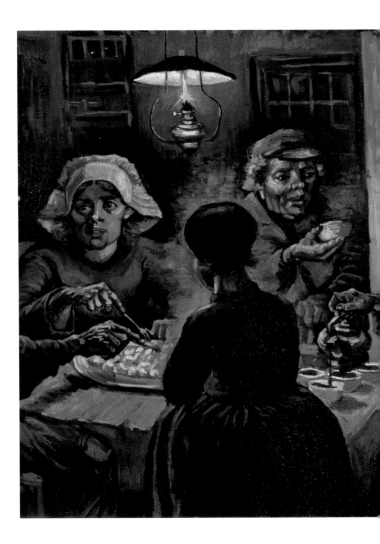

His figures with their coarse skin and weathered hands are seen clutching forks, grabbing potatoes and pouring from a jug. The dark interior references the relationship between the individuals and the earth from which they extracted their meal.

The Potato Eaters was not received well by the artistic community, which did not appreciate Van Gogh's modern style. His figures were criticized both for their ugliness and their anatomical inaccuracies. Despite the negative reception, the painting marked a turning point in his career. He learned the lessons of overworking a picture and thereafter did not expend nearly as much time and energy on a single picture.

From the early 1880s Van Gogh began to sketch images of the 'sower' working or strolling through the fields. He revived the subject again in 1888 during his time in Arles, when painting such themes as the harvest and blooming fruit trees. Arguably, the figure of the lone sower working the field is an empathetic symbol for the struggling artist labouring over his canvas.

The image of the sower remained an obsession throughout Van Gogh's career. In his later paintings of the figure, the 'sower' is replaced by the 'reaper', a somewhat darker character. For example, *Wheatfield with a Reaper* (*see* page 78), painted in 1889, is a canvas largely dominated by a dishevelled yellow wheat field in the foreground, against a looming backdrop of bluish-purple hills. In Van Gogh's own words, 'In this reaper – a vague figure working like the devil in the intense heat to finish his task – I then saw the image of death, in the sense that the wheat being reaped represented mankind.' He went on to reveal to Theo, 'There's nothing sad about this death. It happens in broad daylight, under a sun that bathes everything in a fine golden light.'

Competing Influences and Subjects

Distinct from other Post-Impressionist painters, Van Gogh repeatedly turned to English art and literature. The link is evident in paintings such as *Van Gogh's Chair* (*see* page 60). The chair is at once an homage to Charles Dickens (1812–70) and a symbolic self-portrait. The emptiness is quite possibly a reference to Van Gogh's own mortality and a reminder that his only legacy would be his work. In a letter to Rappard in 1882, he wrote, 'I am organizing my whole life so as to do the things of everyday life that Dickens describes. ...'

Another subject that fired Van Gogh's enthusiasm was the Japanese print, which was all the rage in 1860s Paris. His passion was ignited when he was first introduced to Japanese art during his time at the art academy in Antwerp. It intensified when Japanese prints exploded on the Parisian art scene after being exhibited at the World's Fair in Paris in 1867.

Despite his interest in English and Japanese culture, Dutch and French influences were always more important to Van Gogh. Though he also painted scenes of café life, portraits and still lifes, natural subjects such as panoramic landscapes, haystacks, olive and cypress trees, and wheat fields always remained his most preferred theme.

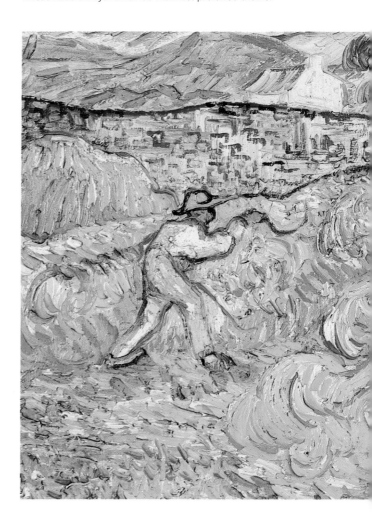

Moving on from the blossoming fruit trees that he repeatedly painted in Arles, olive, cypress and pine trees became a popular theme for Van Gogh during his stay in Saint-Rèmy. In paintings such as *Undergrowth with Two Figures* (*see* page 110), he depicts the base of pine trees as seen from the ground, surrounded by overgrown foliage with ivy creeping up the trunks. To Theo he explained, 'Seeing as life takes place mainly in the garden, it is not so very sad.' Although he was confined to the grounds of the asylum, Van Gogh was comforted by the nature that surrounded him.

It was also at Saint-Rèmy that he began to experiment with olive trees, as these types of trees were not found in Arles. He created a series on the theme, finding both their odd shape and colour interesting. He wrote to Theo, 'It is silvery, then blue, and then a whitish bronze-green, against a yellow, mauve-pink or orange to dull red ochre soil. But difficult, very difficult to capture.'

Though he was so often drawn to objects from nature, he did on occasion long for human subjects, which at times were not easily attained. While in Arles, awaiting Gauguin, he confided in Bernard, 'I cannot work without a model.... Others may have more lucidity than I do in the matter of abstract studies, and it is certainly possible that you are one of their number, Gauguin too and perhaps myself when I am old. But in the meantime I am still feeding off nature. I exaggerate, sometimes I make changes in a motif; but for all that, I do not invent the whole picture; on the contrary, I find it ready in nature, only it must be disentangled.'

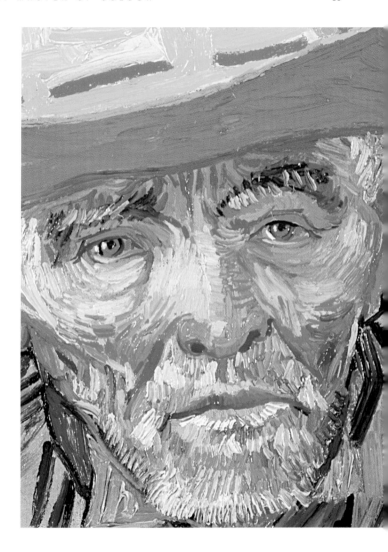

Depending on his location, Van Gogh selected models from both the city and the country, but he always leaned towards the working class, choosing servants, agricultural workers and weavers in the country, and prostitutes and paupers in the city.

Self Portraits

It is true that Van Gogh was not always able to afford models when in Paris, which could be why he painted so many self-portraits. Whatever the reason, the self-portrait gives a more intimate account, not only of his progression as an artist but also of the way in which he saw himself. *Self-portrait with a Straw Hat* (*see* page 48), for instance, is rendered with loose, sketchy brushstrokes and light colours. Despite Van Gogh's penetrating green eyes, the effect is quite casual and airy. There is no visible evidence of his profession. In contrast, *Self-portrait as a Painter* (*see* page 61) is a more ambitious depiction of the artist at work. Rather than gazing out at the viewer, the canvas demands the subject's attention. The tools of his trade are not only clearly visible but they are propped up against the edge of the picture so as not to be missed. His choice of colours – bold blues against the orange of his hair and beard – is also more powerful. And with regard to the changes in his personality, one is confronted with a polished gentleman hard at work yet calm and collected.

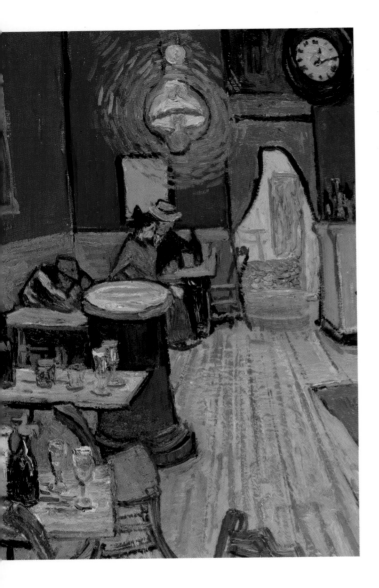

In *The Portrait of a Peasant (Patience Escalier)* (*see* page 65), for instance, he reveals every wrinkle on the weather-worn face of the gardener/ shepherd. *The Zouave*, a young soldier shown wearing his North African regiment uniform, was, according to the artist, 'a boy with a small face, a bull neck and the eye of the tiger'. The postman, Joseph Roulin (proudly sporting his bright blue uniform in his portrait, *see* page 85), possessed a 'Socratic nose', which Van Gogh sought to capture. More than by the close study of their physical features, Van Gogh sought to personalize his subjects by using just the right setting and just the right colour to bring out their true characters. As he expressed in a letter to Theo, 'I want to paint men and women with that something of the eternal which the halo used to symbolize, and which we try to convey by the actual radiance and vibration of our colouring.'

The Artists' Co-operative

Van Gogh was always keen to collaborate with other artists and, inspired by the Parisian art community, he made several unsuccessful attempts at developing his own artistic collective.

While living in Nuenen, he worked briefly with Rappard. The two shared an interest in rural subjects and individually they embarked on a series of paintings involving weavers. Though they remained friends, their working relationship ended when Van Gogh entered the art academy in Antwerp and later relocated to Paris.

As a native Dutchman, his position in Paris enabled him to observe the art world from an objective point of view. He often complained of the pettiness he saw between competing artists and thought that it would be far more beneficial to join forces. He instigated social gatherings to bring artists together in the hopes that it would provide a forum to share ideas and discuss their work. More importantly, he started the trend of exchanging works – an activity that allowed artists to learn from and support one another. He coined his collective the 'artists of the petit boulevard' and organized informal exhibitions showcasing their work, hoping to attract the attention of dealers and buyers.

Later, in Arles, he met Eugène Boch (1855–1941), a Belgian artist who, according to Van Gogh, 'dreams great dreams [...] who works

Van Gogh occasionally painted portraits – a fickle subject for him since it so much depended upon the availability of sitters and his interest in painting them. He found it easier to approach men than women, as the former would often be willing to comply for a few free drinks. The summer of 1888 and into 1889 was a particularly prolific period for his portraits. Inspired by Dutch Golden Age painter Frans Hals (1580–1666), Van Gogh had an uncanny ability to capture the character of a range of different subjects and depicted them with photographic realism.

as the nightingale sings, because it is in his nature'. The two painters were enthusiastic about each other's work and together hashed out new ideas which each would pursue. Van Gogh painted Boch's portrait and later he would feature a likeness of the portrait, which he named *The Poet*, in his painting of *The Bedroom* (*see* page 79). Boch, inspired by his friend's tales recalling his days as a missionary in the Borinage, returned to Belgium to paint scenes featuring mining communities.

The closest Van Gogh came to realizing his co-operative was when Gauguin joined him in Arles. Though he had longed to collaborate with another artist, he began to lose confidence in his own work whilst sharing a studio with Gauguin. Disagreements over methods and materials put a strain on their working relationship. Van Gogh had hoped that other artists would join them but, due to his mental breakdown, their partnership was short-lived and from that point on he worked independently.

Exhibitions

In the spring of 1887 Van Gogh organized his first informal exhibition, at which he displayed his collection of Japanese prints alongside his own paintings and works by colleagues such as Bernard and Toulouse-Lautrec. He then staged a second exhibition at the Grand Bouillon Restaurant du Chalet on the Avenue de Clichy.

Later that year, his work was exhibited in Le Tambourin café and between September 1888 and April 1890 his work was exhibited on three separate occasions.

He participated twice at the Salon held by the Société des Artistes Indépendants (the Salon des Indépendants) in Paris. In 1889, being a new member of the Salon, he was restricted to just two works. Theo chose *Starry Night*, 1888 (*see* page 58), and *Irises*, 1889 (*see* page 93).

That same year he was invited to participate in annual exhibition of the avant-garde group Les Vingt ('The Twenty') in Brussels. This was his most important exhibition to date, as the exclusive Les Vingt granted artists international recognition. Putting his best work

forward, he exhibited two sunflower paintings, two landscapes from Arles and two from Saint-Rémy, one of which depicted a view from his window at the asylum.

In 1890, for Van Gogh's second inclusion in the Salon, Theo submitted 10 paintings. His exclusive choice of landscapes confirms Van Gogh's strength in his depiction of nature over his skills as a figure painter. Van Gogh did not come close to achieving the recognition that his work has today. However, his contribution to art was just starting to be appreciated towards the end of his life.

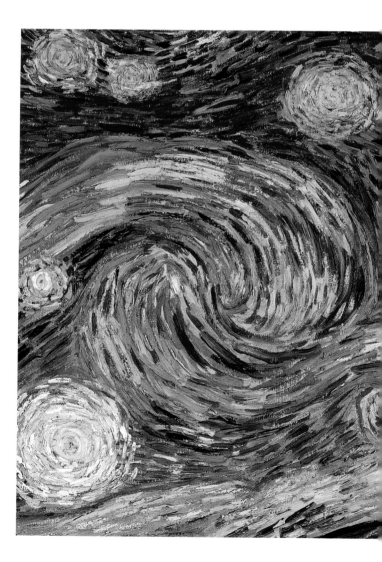

Support from Friends and Family

He received praise and encouragement from friends and family regarding his earliest exhibitions with the Salon and Les Vingt. In a letter of congratulation, Gauguin wrote, 'I send you my sincere compliments, and to many artists you are the most noteworthy part of the exhibition.'

Theo had no doubt that his brother was destined to become one of the most important artists of his age. He wrote to Van Gogh, 'it seems that the exhibition of Les Vingt at Brussels is now open; I read in a paper that the canvases that arouse the curiosity of the public the most are the open-air study by [Paul] Cézanne [1839–1906], the landscapes by [Alfred] Sisley [1839–99], the symphonies of Van Gogh and the works of [Pierre-Auguste] Renoir [1841–1919] ... I think we can wait patiently for success to come; you will surely live to see it.' Van Gogh sold one painting in Brussels, *The Red Vineyard at Arles* (*see* page 59), which he painted in Arles in 1888.

Despite his occasional outbursts and inability to take criticism, constructive or not, Van Gogh's eccentric personality attracted artists, who admired the commitment he had to his work and found his open-mindedness towards a variety of cultural influences refreshing.

His friendship with Toulouse-Lautrec proved to be one of the most enduring. In an effort to defend his friend against the harsh criticism of Henry de Groux (1866–1930), a member of the group Les Vingt who refused to have his paintings hung next to Van Gogh's, Lautrec challenged him to a duel. The challenge was not accepted but the friendship between Van Gogh and Lautrec would last throughout their lives.

In January 1890, the art critic Albert Aurier published a positive review of Van Gogh's paintings in the *Mercure de France*, linking him to established artistic groups that set the pace for French art, such as the Symbolists, who emphasized fantastical depictions, and Les Nabis, renowned for their metaphysical representations in painting. Sadly, Van Gogh was his own worst critic and could not accept the compliment. His reaction to Aurier's praise is documented in a letter that he sent to the critic, in which he wrote, 'For the role attaching to me, or that will be attached to me, will remain, I assure you, of very secondary importance.'

Van Gogh underestimated his influence. By the early 1900s, artistic groups, most notably the French Fauves ('Wild Beasts') and German Expressionists, revered Van Gogh as a principal figure in the history of modern art.

PLACES

During his life and for the time in which he lived, Van Gogh travelled quite widely. Perhaps with each new change of scenery he had hoped to find happiness, which sadly he never did. However, his travels were invaluable in shaping his international approach to art. He was exposed to a variety of artistic trends and made acquaintances with some of the most influential artists of his day.

Holland (The Netherlands)

Van Gogh periodically went back to his homeland, the Netherlands, throughout his life, sometimes returning to his parents' home out of financial or health-related necessity, other times retreating to the comfort of the familiar countryside to escape his hectic city lifestyle, notably the excesses of Paris.

Born and raised in the rural Brabant countryside of Zundert, Van Gogh enjoyed an active childhood surrounded by nature, which had a profound influence on his art. In a nostalgic letter to Theo written in 1882, he reflected upon 'surroundings that taught us to think more than is usual ... precisely the quality one has to have in order to paint'. His passion for nature never waned. He drew inspiration for his paintings from both the frequent walks that he took and the romanticized landscapes of his remembered childhood.

In 1876, at the tender age of 16, Van Gogh left home to embark on his career as an art dealer for Goupil & Cie in The Hague, becoming their youngest-ever employee. Seven years later, following his rejection of an art-dealing career, he returned to his parents' home in Etten, a village in the province of Gelderland, where he stayed for a year. In late 1881, he returned to The Hague to pursue his career as an artist and there he met other Dutch painters, many of whom were also working in a Realist vein, drawing and painting from life.

When the city became too much for him, Van Gogh moved to the remote Drenthe countryside, where he remained for only three months before loneliness overcame him. By December 1883 he moved back to the home of his parents, who had since moved from Etten to the parish

town of Nuenen, in North Brabant. During his 18-month stay in Nuenen he painted several simple scenes depicting his rural surroundings, often featuring buildings. For instance, *Landscape with a Church and Houses* is a work in which he represents the relationship between the buildings and the land in which they stand, primarily achieved by his use of earthy colour tones and effective use of perspective. The old dilapidated church tower would become a frequently used motif.

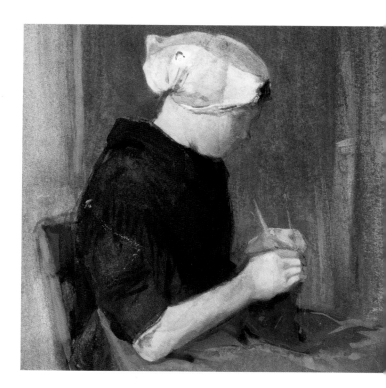

London

From 1873 to 1875 Van Gogh worked for the London branch of Goupil & Cie on Southampton Street, close to Covent Garden.

Despite finding the cost of living exceedingly high and suffering from homesickness, he liked his surroundings. He was impressed by the beautiful countryside on the outskirts of London and enjoyed strolling around the parks, especially Rotten Row in Hyde Park, 'where hundreds of ladies and gentlemen ride on horseback'.

He found lodgings at the home of widow Ursula Loyer, and shortly afterwards fell in love with her daughter, Eugenie. When he discovered that she was engaged, he sank into a deep depression. In the face of unrequited love, Van Gogh forcefully turned to religion and his character shifted to that of a melancholic recluse.

Artistically, English literature had a profound impact on Van Gogh. He fell under the spell of nineteenth-century novelists such as Dickens and George Eliot (1819–80). That said, it took him some time to appreciate English art. In a letter to Theo he revealed, 'At first English art did not appeal to me; one must get used to it. But there are clever painters here.'

He admired works by many of the Old Masters, such as John Constable (1776–1837), J.M.W Turner (1775–1851), Joshua Reynolds (1723– 92), Thomas Gainsborough (1727–88) and, most significantly, John Everett Millais (1829–96), one of the founders of the Pre-Raphaelite Brotherhood. In Millais' work Van Gogh particularly admired his direct approach, realistic depictions of nature and expert draughtsmanship.

He strove to familiarize himself with English contemporary art as well. He attended 'Exhibition of Works by Living Artists', the Royal Academy's summer exhibition in June 1874. His first impression of the show was negative; he felt the paintings were 'with few exceptions very bad and uninteresting'.

Eventually, he embraced the Realist movement of the 1870s, which was concerned with social issues and the plight of the less fortunate. He would later refer to this style when he embarked on drawings of the 'low life' in The Hague in 1880.

He found visual comparisons between literature and painting inevitable. In 1880, reflecting on his time in London, he wrote to Theo, 'There is something of Rembrandt in [William] Shakespeare [c. 1564–1616] and of [Antonio] Correggio [1489–1534] in [Jules] Michelet [1798–1874] and of Delacroix in Victor Hugo [1802-85].'

English illustrations were also a source of major influence for Van Gogh. He collected magazines such as The Illustrated London News, Punch and Harpers and Graphic, all of which contained illustrations alongside current news events. Graphic was the publication that had the greatest impact, but it was not until a decade later that his passion for English illustrations and literature began to appear in his own work.

He returned to London briefly in 1876 to take up a voluntary position as a teacher's assistant, initially in Ramsgate then in Isleworth. On the heels of his fleeting teaching career, he delivered his first sermon at a church in Richmond.

Paris

Van Gogh lived in Paris in 1875 while working for the Paris branch of Goupil & Cie, but it was not until March of 1886, upon the

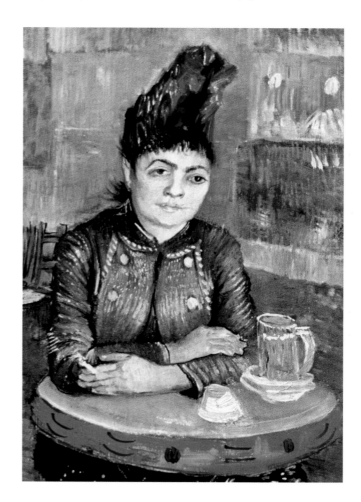

encouragement of Theo, that he permanently relocated to Paris to fulfill his artistic endeavours.

He lived with Theo in Montmartre, who in the meantime had been promoted to the position of manager at Goupil & Cie, which was at that time trading as Boussod, Valadon & Cie. Paris was the artistic capital of the western world and Montmartre especially was the breeding ground for the avant-garde.

Van Gogh arrived just in time for the last Impressionists' group exhibition and for the first time he was exposed to the new style. Through Theo he had the opportunity to meet many of the artists, some of whom would become lifelong friends.

Though he fully embraced the Parisian lifestyle (while at the same time not losing touch with his Dutch roots) and socialized with artists such as Toulouse-Lautrec, Bernard and Gauguin, Van Gogh took his time absorbing his new surroundings.

He began observing the local flavour by strolling down the wide Parisian boulevards and along the banks of the River Seine, and frequenting popular restaurants and cafés. His other favourite haunts included Père Tanguy's (1825–94) paint shop and Siegfried Bing's oriental emporium, where he and Theo purchased dozens of Japanese prints for their collection.

Unsurprisingly, Van Gogh also visited Paris's museums. Not limiting himself to contemporary French art, he familiarized himself with the work of Parisian masters such as Delacroix during his many visits to the Louvre.

He did not immediately adopt the Impressionist style, including a lighter palette, but in his usual methodical artistic manner, he took one year to develop his newly learned techniques. The many self-portraits Van Gogh painted during his time in Paris demonstrate a steady progression of his experimentations with colour and the implementation of Impressionist techniques as he interpreted them. In a letter to Theo he confided, 'My intention is to show that a variety of very different portraits can be made of the same person.'

In Paris, Van Gogh painted many scenes of city life and experimented with different perspectives in regard to cityscapes. For example, *View of Paris from Theo's Apartment in the Rue Lupic*, painted in 1887, demonstrates his eagerness to master the different positions, angles and shapes of a jumble of clustered buildings.

Following in the footsteps of the Impressionists, he would often head to the outskirts of the city – to suburbs such as Asnières – seeking a calmer environment in which to work. In a letter to his sister he wrote, 'When I painted the landscape in Asnières this summer, I saw more colours there than ever before.'

Paris proved most beneficial in both exposing Van Gogh to successful artists and introducing him to the latest trends, but ultimately the city came close to overwhelming him. He confided in Theo, 'It appears to me to be almost impossible to work in Paris.'

Arles

Finding Paris wearying, distracting, expensive and cold, Van Gogh sought refuge from the city once again. In February 1888 he set off for Arles to satiate his yearning to experience the colours of the South.

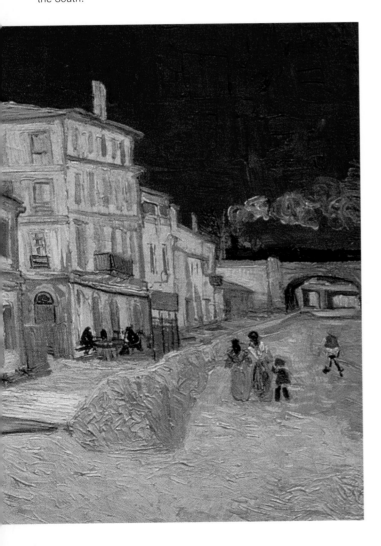

Initially, he took up lodgings at a local hotel but shortly after, in September 1888, he rented the famous (or perhaps infamous given the events it was witness to) Yellow House on Place Lamartine, nestled in between the rail tracks and river on the north side of town. There Gauguin lived with Van Gogh, at his insistent invitation, for a short period of time. The arrangement came to a traumatic end after which Van Gogh visited L'Espace, the hospital in Arles where his left ear was bandaged after he had sliced off its lobe.

Van Gogh's Arles phase was highly prolific. He created approximately 187 paintings within a 16-month period, out of which emerged his most stunning masterpieces, including *The Café Terrace* (*see* page 74), featuring the now famous Café Van Gogh on the Place du Forum, *The Yellow House, Arles* (*see* page 54) and *The Bedroom* (*see* page 79).

During this time Van Gogh's machine-like work ethic was driven by his desire to churn out paintings in the hope of making a sale, perhaps to justify his financial reliance on Theo for materials or to pay back some of his brother's investments over the years. He set himself ambitious targets and did not let the weather stand in his way: when it was not possible to paint outdoors, he returned to the studio to paint still lifes.

Van Gogh's passion for drawing and sketching was rejuvenated during this time and he kept himself informed of the latest artistic trends in Paris via his correspondence with Theo. Enthusiastic about his endeavours in Arles he wrote, 'I feel that in these surroundings there is everything one needs to do good work. So, it will be my own fault if I don't succeed.'

By this point, art had become his religion. For example, on a short excursion to the village of Les Saintes-Maries-de-la-Mer, the legendary resting place of the three Marys (Magdalen, Jacobe and Salome) and a celebrated site of Catholic pilgrimage, Van Gogh was far more interested in the seaside, the multicoloured boats and the fishermen's thatched and whitewashed cottages. Earlier in his life a visit to such a place would have put matters of religion high above his artistic agenda.

Saint-Rémy-de-Provence

Although he had recovered from the mental breakdown suffered in the Yellow House that he shared with Gaugin, Van Gogh feared a relapse and so voluntarily committed himself to the psychiatric hospital Saint-Paul-de-Mausole at Saint-Rémy in 1889. His convalescence meant he did not return to his work at quite the same feverish pace, but he did continue to paint whilst in hospital.

He suffered from the occasional psychotic attack but during periods of clarity he was able to concentrate on his work and, arguably, the process of working was therapy in itself. Hoping to regain his health by throwing himself into his work, he divided his time between works that he considered to be creative studies or exercises and works that he felt were worthy to exhibit amongst his peers.

This delineation between work and health was further distinguished by the fact that he kept two rooms: one for resting, the other for working. The regulated nature of the day in the hospital – time to eat, time to sleep, time to walk in the gardens – also proved beneficial in keeping him tied to a regular work schedule.

Limited to painting the hospital grounds, Van Gogh created works such as *The Garden of St Paul's Hospital*. The hospital was surrounded by gardens where Van Gogh enjoyed leisurely walks, but there were times when the doctors instructed him to remain indoors. When so confined, he would paint the view from his window, which looked out at the ridge of the Alpilles.

Auvers-sur-Oise

In the summer of 1890 Van Gogh settled in the small country town of Auvers-sur-Oise just outside of Paris. Following the suggestion of fellow artist, Camille Pissarro (1830–1903), he came to reside at the home of Dr Paul Gachet (1828–1909).

Gachet, renowned for his homeopathic remedies, was a friend to several of the Impressionists and as such, his home was decorated with many of their paintings. This, combined with the fact that he was

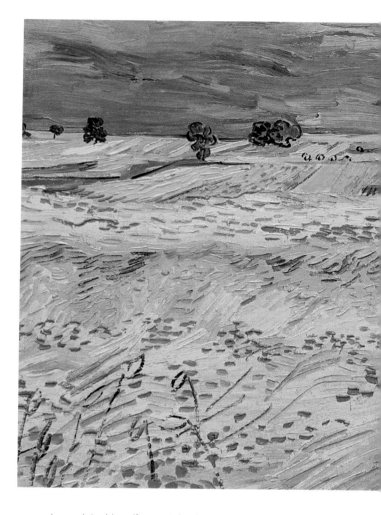

an amateur painter himself, meant that he and Van Gogh had much to talk about and the two quickly became friends.

The doctor's encouragement led a rejuvenated Van Gogh to resume his work with all the fervour of before, resulting in a series of portrait and landscape paintings. Rather impressively he churned out nearly one painting a day within a two-month period.

Alongside a flurry of unfinished sketches and studies, several masterpieces emerged, such as *Plain at Auvers* (*see* page 112), *Chestnut Trees in Blossom, Auvers-sur-Oise* (*see* page 113) and *Bank of the Oise at Auvers* (*see* page 118), inspired by the picturesque Auvers landscape.

He also revisited former interests: peasant life, evident in paintings such as *The Young Peasant Girl in a Straw Hat Sitting in a Wheatfield*; still lifes, such as *Roses* (*see* page 107); and portraits in particular, with *Marguerite Gachet at the Piano* (*see* page 115) featuring Gachet's daughter.

Country life suited him well and he enjoyed a short period of time in which he felt healthy. In a letter to Theo he wrote, 'I'm all but certain that in those canvases I have formulated what I cannot express in words, namely how healthy and heartening I find the countryside.'

There were, of course, paintings that betrayed Van Gogh's ever-present dark side. Most unsettling are his depictions of vast, empty fields that reveal the unending sadness that eventually drove him to take his own life.

STYLES & TECHNIQUES

Van Gogh is considered a Post-Impressionist, a term applied to artists who were influenced by the French Impressionists. The two groups shared an affinity for working outdoors, but where the Impressionists' agenda was to represent nature seen through the naked eye, the Post-Impressionists experimented with a more expressive or symbolic approach.

Working Outdoors

Van Gogh endeavoured to capture the expressiveness of nature. So dedicated was he to the genre of landscape painting that even when he was confined indoors during various periods of convalescence, he would paint the view from his window.

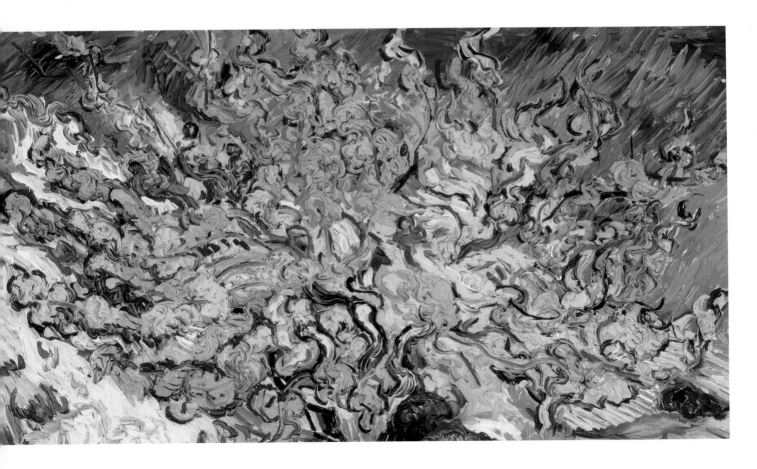

Though he painted many outdoor scenes in Paris, both cityscapes and suburban vistas, Van Gogh's relocation to the South of France in 1888 enabled him to take full advantage of a location where he could experience the changes of the seasons, witness spring in bloom and experiment with depictions of the changing effects of light and colour.

Of his time in Provence he wrote, 'I'm up to my ears in work, for the trees are in blossom and I want to paint a Provençal orchard of astounding gaiety.' He did just that, completing over a dozen studies of ripe fruit trees within a one-month period. Producing a series of paintings that used the same theme was by now a common practice among the Impressionists, most notably in the work of Claude Monet (1840–1926).

Though there were many benefits to painting outdoors, such as capturing the slightest variances of light so as to represent daily and seasonal changes, for Van Gogh there was also a downside. He was continuously obsessed with turning work around as quickly as possible, as he was frantically hoping he could convert his work into sales. He worried about the quality of the works that he completed outdoors on account of their 'sketchy' appearance. In a letter to Theo, he proposed a solution to his dilemma: 'If I can manage to learn to work out studies from nature on a fresh canvas, we should profit by it, as far as the likelihood of selling is concerned.'

To develop his skills in mastering perspective, Van Gogh concentrated on his domestic surroundings. For example, he created a series of studies based on objects such as windows, chairs, tables and the contents of his bedroom.

He started working with a small perspective frame as early as 1881 and within a year he constructed a frame large enough to take outdoors. This device acted as a window through which he could view scenes from nature in a more structured way. In a letter to Theo, he described his experience with the device: 'To turn this spyhole frame on the sea, on the green meadows, or on the snowy fields in winter, or on the fantastic network of thin and thick branches and trunks in autumn or on stormy day ... Long and continuous practice with it

enables one to draw quick as lightning – and, once the drawing is done firmly, to paint quick as lightning too.'

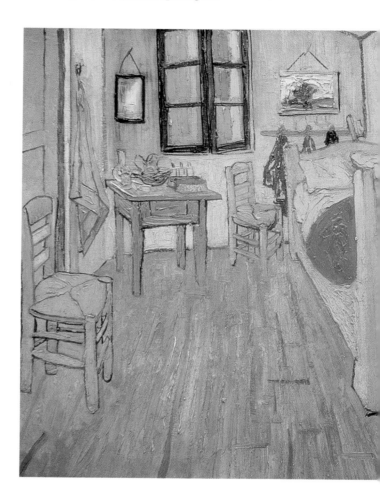

Changing Palette

Van Gogh's earliest artistic output was drawing. Even before he fully committed to a career as an artist, he was sketching his surroundings in London, whilst working as an art dealer. As he became more serious in his artistic endeavours, he concentrated on the human figure. He worked alone but relied on Theo, who was working in Paris at the time, to supply him with French drawing manuals, such as Charles Bargue's *Exercises au fusain* and *Cours de dessin*. Initially he worked exclusively in black and white.

As he began to incorporate colour within his drawings using pen and ink, and graphite, he applied numerous pen strokes which were loosely drawn, and incorporated patterns and textures to create depth of space. Later, when he began to paint, he juxtaposed large expanses of rich colour to achieve the same effect.

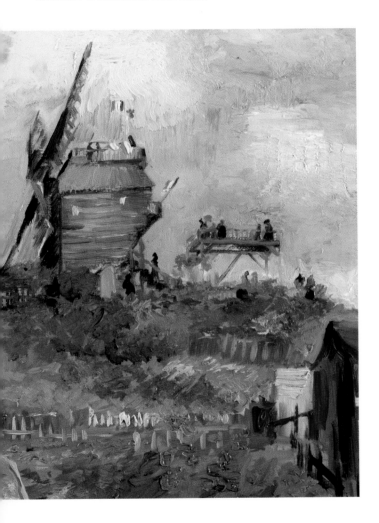

Mastering accuracy in figure drawing was a priority for Van Gogh from the outset. Initially, he struggled to achieve accuracy in painting groups of figures that were anatomically correct and logically placed within the picture frame. For example, *The State Lottery* was an early attempt at arranging figures using watercolour with a predominantly brown, earthy subdued palette.

When he began to paint, he favoured a dark, earthy palette as demonstrated in paintings such as *Head of Peasant Woman*, one of a series of small studies he created in preparation for his larger painting *The Potato Eaters*, completed in 1885. The figure's white collar and cap stand out starkly against the greys, browns and blacks that fill the canvas.

Inspired by the pastel hues of the Impressionists, Van Gogh's palette lightened considerably while he was in Paris from 1886–88. *Terrace in the Luxembourg Garden*, painted in 1886, is one such example in which Van Gogh chose a considerably lighter combination of colours. Depicted is a scene underneath a pale blue sky, with light streaming through the pea-green leaves on the trees and reflecting off the pale beige pavement. By contrast, his figures meandering along the terrace feature strong primary red, yellow and blue colouring.

During his Parisian phase, Van Gogh not only experimented with a lighter palette, but he also began to explore the use of vibrant, saturated colour as inspired by the many Japanese prints that he and Theo collected.

Japanese prints emphasized flat geometric forms, vibrant colour combinations and asymmetrical compositions, which attracted Van Gogh immensely. He was enthralled most of all by the use of pure, saturated colour and the juxtaposition of vibrant colour planes within the picture frame. It enabled him to realize the power that colour has to evoke emotional responses.

He began to incorporate not only the new colour techniques that he learned, but also Japanese motifs such as bamboo, frogs and cranes. The influence of Japanese prints can be observed in his most famous masterpieces, such as *Sower with Setting Sun* (*see* page 68), *The Yellow House* (*see* page 54) and *The Bedroom* (*see* page 79), all painted in 1888.

For example, *Sower with Setting Sun* is comprised of a dark figure set in the foreground underneath a vibrant yellow setting sun, while an equally dark twisting tree trunk cuts across the canvas, dividing the image in half. The dark figure of the sower and the tree contrast the

unnaturally bright colour blocks of yellows, purples and blues. Such asymmetrical composition and flat forms are typical of Japanese prints.

In the painting *The Yellow House* the Japanese compositional style is less obvious but its influence is undeniably present. The lemon yellow house with its green door and shutters sits on the corner surrounded by a cluster of buildings of the same colour under 'a sky of pure cobalt'. Wide streets engulf the foreground with only a few figures walking along the pavement. The yellow and blue colour blocks are harmoniously contrasted. In a letter to Theo accompanied by a drawing that Van Gogh produced after the painting, he wrote, 'What a powerful sight, those yellow houses in the sun and then the unforgettable, also the clarity of the blue [sky].'

The flattened form of the buildings – the house in particular – is comprised of two flat planes distinguished only by the use of varying yellow colour tones. The Japanese influence can be seen in the lack of contrast between light and shadow. A further debt to the Japanese style can be seen in the spatial effects that he created merely with his manipulation of colour and the tilting of the planes to evoke depth of space.

Colour Working with Perspective

The Bedroom is a personal account of Van Gogh's living quarters inside the Yellow House and an insight into his monk-like existence. Sparsely furnished, the room contains only a bed, chair, nightstand, window and a mirror. The paintings hanging over his bed are his own portraits, *The Poet, Portrait of Eugène Boch* (1855–1941) and *The Lover, Portrait of Paul-Eugène Milliet* (1863–1943).

Despite the sparseness, Van Gogh makes his presence known with the placement of the towel hanging from a peg on the wall and the window left open just a crack. The bold colours contrast yet complement each other, the forms have been flattened, and there is a lack of shadowing, characteristic of the Japanese print. The objects are slightly and purposely tilted towards the viewer's gaze. Thus, the choice to forgo accurate perspective is deliberate. Interestingly, Van Gogh's colour choices, which are on the warm side, are also carefully picked in order to evoke feelings of restfulness.

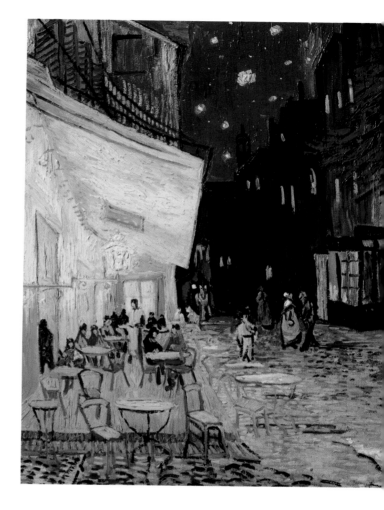

His manipulation of colour is further exemplified in works such as *The Night Café* (*see* page 57) and *The Café Terrace on the Place du Forum, Arles, At Night* (*see* page 74). Painted in 1888, *The Night Café*, modelled after the Café de la Gare that Van Gogh frequented, demonstrates his masterful use of colour to evoke emotion and his manipulation of perspective to direct the viewer's gaze. Depicted is a skewed, almost bird's-eye view of the interior of a café. Slightly off-centre is a green billiards table that leads one's eye to the curtained doorway in the background.

The fiercely glowing gas lamplights that hang from the green ceiling, set against the contrasting red walls and yellow floorboards, create undeniable tensions, which Van Gogh fully intended. Describing the

composition to Theo, he wrote, 'I have tried to express the terrible passions of humanity by means of red and green. The room is blood red and dark yellow with a green billiard table in the middle; there are four lemon-yellow lamps with a glow of orange and green. Everywhere there is a clash and contrast of the most alien reds and greens, in the

luminous green.' He famously added that *The Night Café* is 'one of the ugliest pictures I have done'.

In contrast, *The Café Terrace* achieves just the opposite result. It is a calm, harmonious scene in which Van Gogh, through his masterful use of colour, has perfected the effects of natural and artificial light. He accomplishes this by using complementary contrasts of yellow and blue, slight dabs of white paint on the windowpanes and an almost imperceptible pale green on the table tops to reflect the light. He demonstrates the effects of a shadow simply by using thick black lines, probably executed in one even brushstroke. Here too, he depicts an active scene with a standing waiter, diners seated at tables and a group of passers-by, but the scene is altogether a peaceful one unfolding under a beautifully cloudless, starlit sky.

Impasto

Van Gogh's signature thick brushstroke was achieved by using a technique called impasto: the layering of paint or texture on to the canvas.

In Paris, where his style underwent the most radical changes, he began experimenting with short, broken brushstrokes as well as pointillism: a technique involving the application of small dots of pure colour developed by Seurat in the mid-1880s.

For example, in the painting *Fishing in Spring, the Pont de Clichy (Asnières)* (*see* page 45), inspired by Seurat, Van Gogh used a combination of short brushstrokes and eloquent, globular dots. His newly learned technique is most prominent in his rendition of the green and yellow leaves on the trees, and the dabs of white paint in the pale blue sky.

His famous swirling brushstroke and heavy black outlines emerged in his later works, accompanied by globs of thick paint that create a textured, tactile painting verging on the edge of relief sculpture.

In no other painting is Van Gogh's swirling brushstroke more evident than in one of his most famous, *The Starry Night* (*see* page 90), which

figures of little sleeping hooligans, in the empty dreary room, in violet and blue. The blood red and the yellow-green of the billiard table, for instance, contrast with the soft, tender Louis XV green of the counter, on which there is a rose nosegay. The white clothes of the landlord, watchful in a corner of that furnace, turn lemon-yellow, or pale

has been described as a field of rolling energy. Depicted is a quiet village under a midnight-blue sky speckled with bright, radiating stars. The effect is almost fantastical. In a letter to Theo describing the painting, Van Gogh wrote, 'Looking at the stars always makes me dream.... Why, I ask myself, shouldn't the shining dots of the sky be as accessible as the black dots on the map of France? Just as we take the train to get to Tarascon or Rouen, we take death to reach a star.'

He acknowledged his departure from representing nature in a subjective way to expressing 'exaggerations from the point of view of arrangement, their lines warped as in old wood'. The lines to which he is referring are what give the painting movement. The only interruption to this movement is the silhouetted cypress tree that intersects the painting, an allusion to death which intersects life, revealing the artist's preoccupation with thoughts of the afterlife.

A More Stylized Technique

During his time in Arles and subsequently Saint-Rémy, Van Gogh's style underwent another change. His work was becoming more stylized. With his twisting brushstrokes he created a graceful flow in which swirls of colour seemed to float within the canvas. Even his juxtaposition of colour seemed more complimentary; for instance, he replaced his usual bold primary colours with softer pastels or similar shades of blues, grey and olive-green.

The best example is *Self-Portrait* (*see* page 94), painted in 1889. Revealing only his head and bust, Van Gogh depicts himself wearing a pale green and blue suit, the exact same colour as the background, which is comprised of vigorous, swirling brushstrokes. He differentiates himself from the background by incorporating a thin, black line around his body and using a much calmer brushstroke for his clothing. With a penetrating, anxious glare, every feature of his face is pronounced: sharp nose, tight lips and furrowed brow. Slightly tilted away from the viewer in a traditionally Dutch three-quarter pose, the only contrast is his bright orange hair and beard.

Though Van Gogh drew inspiration from a variety of sources, he absorbed his influences without mimicking them, always maintaining his

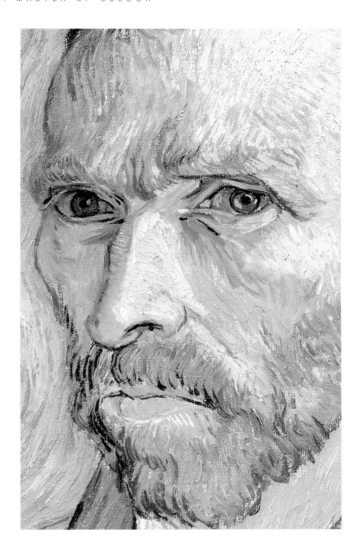

own style. He never forgot his Dutch roots, including the Hague School approach to Realism, which was subjective rather than objective.

His work conveys a sense of urgency and emotion but, most importantly, it is as if with the touch of his paintbrush he has breathed life into the canvas. Van Gogh, well aware of the task at hand, wrote, 'What is required in art nowadays is something very much alive, very strong in colour, very much intensified.' The feeling of movement, such as the wind breezing through a wheat field or stars dancing in the night sky, is just one of Van Gogh's greatest technical achievements.

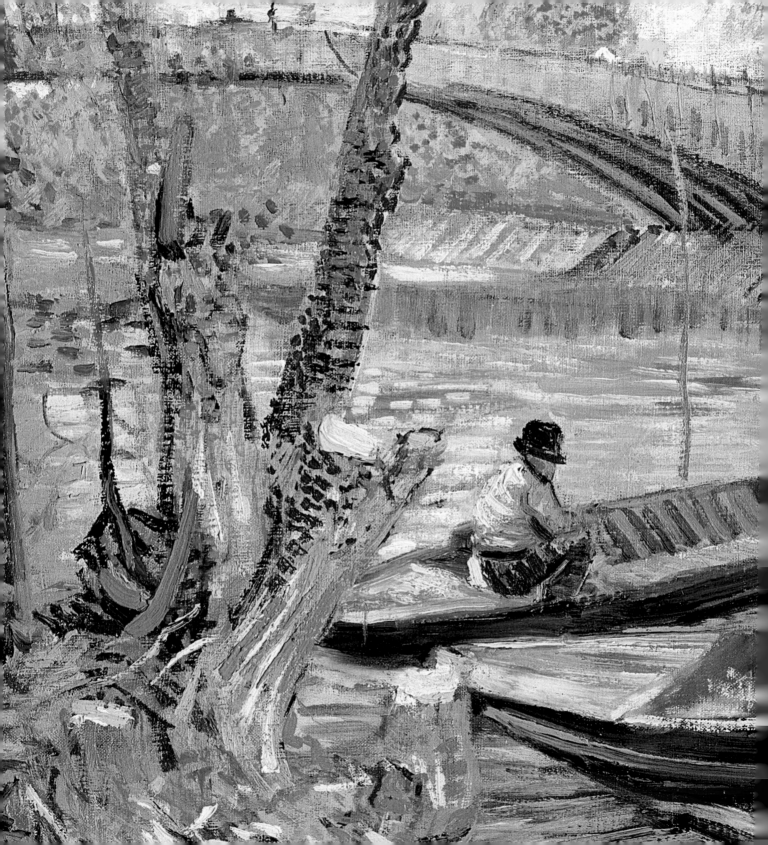

The Netherlands & Paris

After studying with Anton Mauve in The Hague, Van Gogh visited Nuenen in 1883, where he painted in sombre earth tones. In 1886 he returned to Paris, studied with Fernand Cormon, collected Japanese prints, met the Impressionists and lightened his palette.

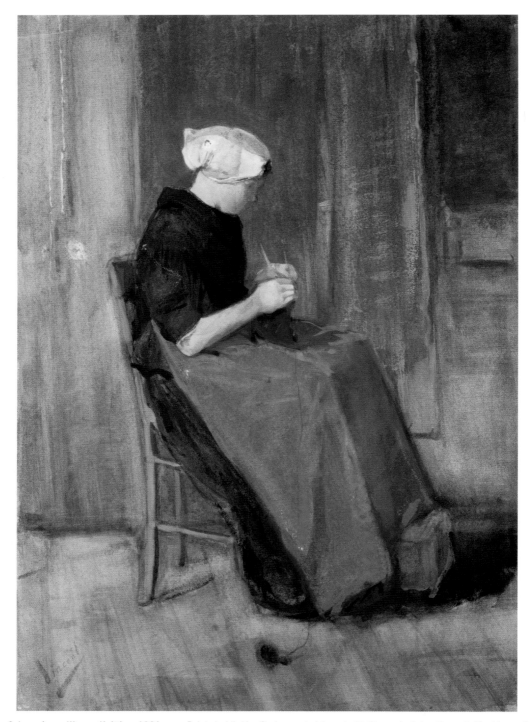

A Young Scheveningen Woman Knitting, 1881
Watercolour and gouache on paper, 52.2 x 36.5 cm
(20½ x 14½ in) • Private Collection

Painted while Van Gogh was studying art with his cousin Anton Mauve in The Hague, this reflects
Mauve's encouragement of Van Gogh to paint still lifes and to try watercolour. The model sat in
Mauve's studio.

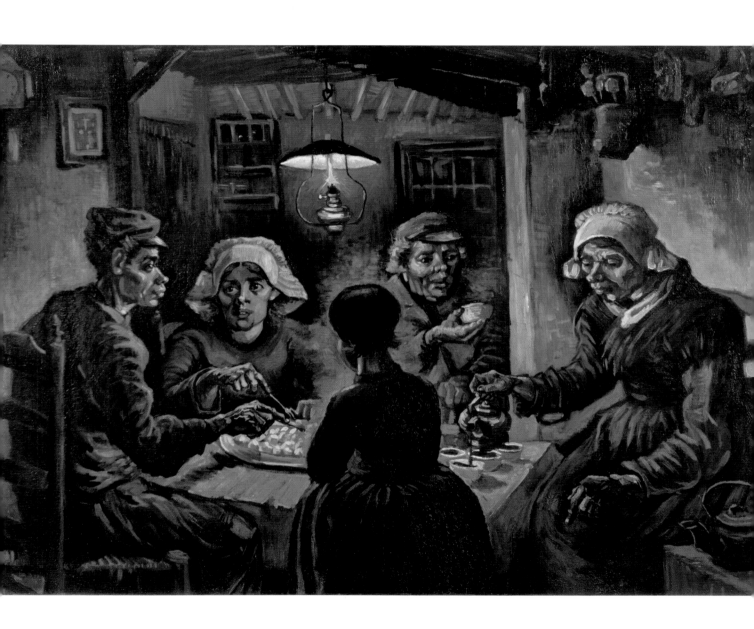

The Potato Eaters, 1885
Oil on canvas, 82 x 114 cm (32¼ x 44⅞ in)
• Van Gogh Museum, Amsterdam

Inspired by artists of the Hague School, Van Gogh painted this in April 1885 while in Nuenen in the Netherlands. It shows the empathy he felt for the peasants with whom he worked and lived at that time.

Le Moulin de la Galette, 1886
Oil on canvas, 45.7 x 38 cm (18 x 15 in)
• Kelvingrove Art Gallery and Museum, Glasgow

When Van Gogh first moved to Paris to stay with Theo in 1886, he painted several versions of the Moulin de la Galette (also known as Le Moulin de Blute-Fin), a popular terrace and dance hall he could see from their apartment in Montmartre.

Vase with Gladioli and China Asters, 1886
Oil on canvas, 46.5 x 38.5 cm (18⅛ x 15⅛ in) • Private Collection

In Paris in 1886, Van Gogh produced many still lifes of flowers, as they were relatively cheap to buy. This was one of those paintings, in which he experimented with brighter colours, looser brushstrokes and thicker paint than before.

Three Pairs of Shoes, 1886–87
Oil on canvas, 49.8 x 72.5 cm (19⅝ x 28½ in) • Fogg Art Museum,
Harvard University Art Museums, Cambridge

This is one of three paintings of worn shoes made by Van Gogh in his early tertiary palette. He applied paint thickly and deliberately, emphasizing the worn appearance of the boots and the obvious poverty of their owners.

Imperial Fritillaries in a Copper Vase, 1887
Oil on canvas, 73.5 x 60.5 cm (28⅞ x 23⅞ in)
• Musée d'Orsay, Paris

Already displaying an influence of Impressionism and Post-Impressionism, these bright spring flowers preceded Van Gogh's famous sunflower paintings by a couple of years. Vivacity is created through juxtaposed complementary colours and pointillist marks.

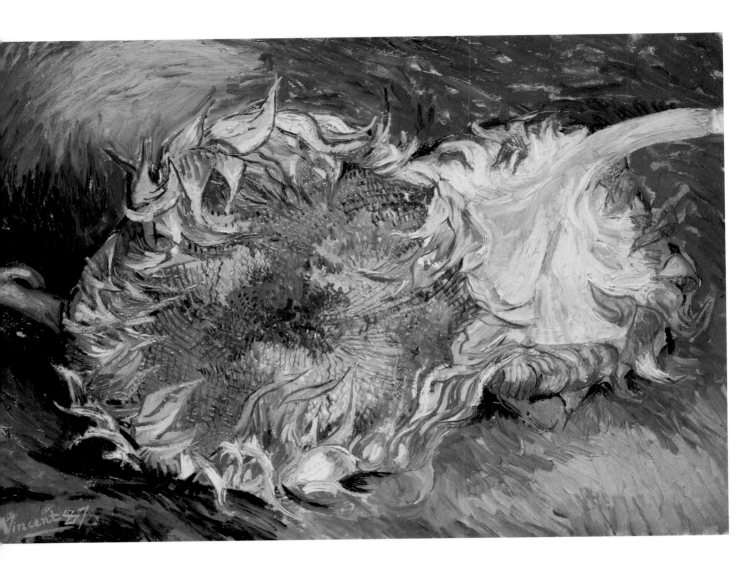

Sunflowers, 1887
Oil on canvas, 43 x 61 cm (17 x 24 in)
• Metropolitan Museum of Art, New York

One of a group of four similar works that Van Gogh painted in late summer 1887 while staying with Theo in Paris, the bold and ragged approach is different from most flower paintings. It was the first time he painted sunflowers.

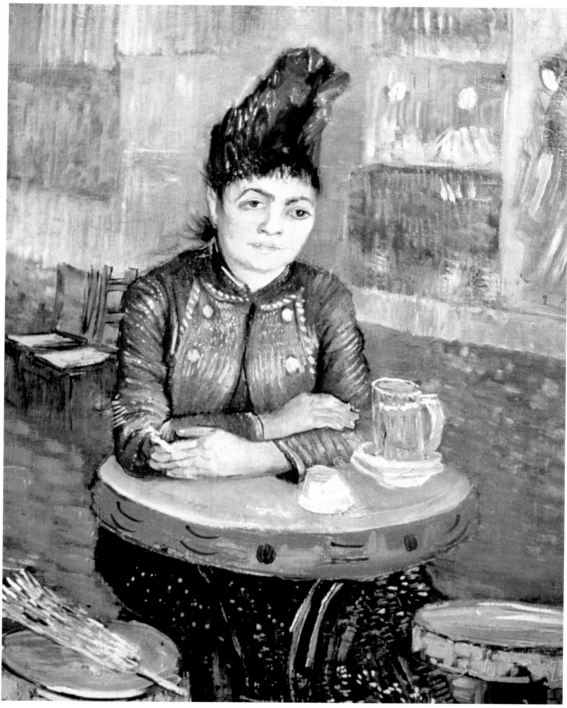

Agostina Segatori in Le Tambourin, 1887
Oil on canvas, 55.5 x 46.5 cm (21⅞ x 18⅜ in)
• Van Gogh Museum, Amsterdam

Fashionably dressed Agostina Segatori, owner of the Café du Tambourin, sits at a table surrounded by an exhibition of Japanese prints. She often displayed art in her café, including several of Van Gogh's paintings.

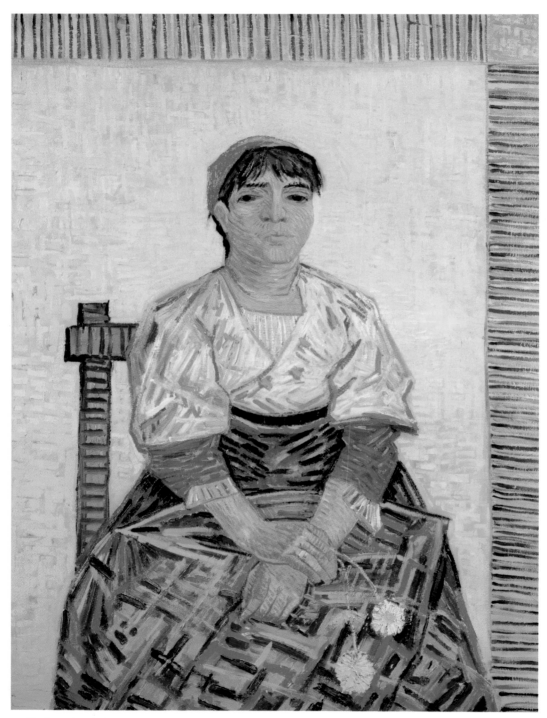

L'Italienne (The Italian Woman), 1887
Oil on canvas, 81 x 60 cm (31⅞ x 23⅔ in)
• Musée d'Orsay, Paris

As well as running the Café du Tambourin, Agostina Segatori modelled for Corot, Gérôme and Manet, and probably had a brief affair with Van Gogh. Here he mixed Neo-Impressionist colour theories with stylistic elements of Japanese art.

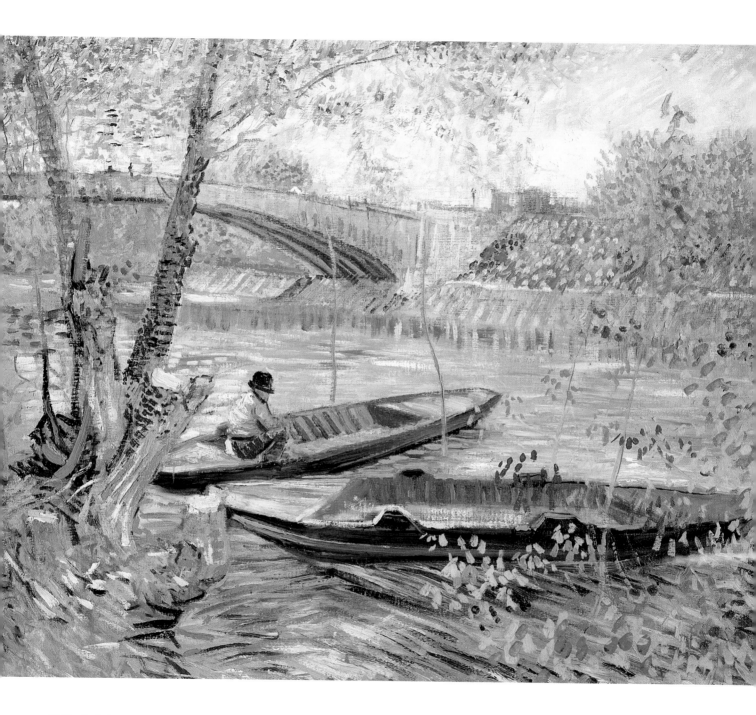

Fishing in Spring, the Pont de Clichy (Asnières), 1887
Oil on canvas, 50.5 x 60 cm (19⅞ x 23⅝ in)
• Art Institute of Chicago, Chicago

When he painted this, Van Gogh had befriended several artists in Paris including Paul Signac (1863–1935), and was fascinated by some of their ideas, such as broken marks and intense colours. He probably painted this alongside Signac.

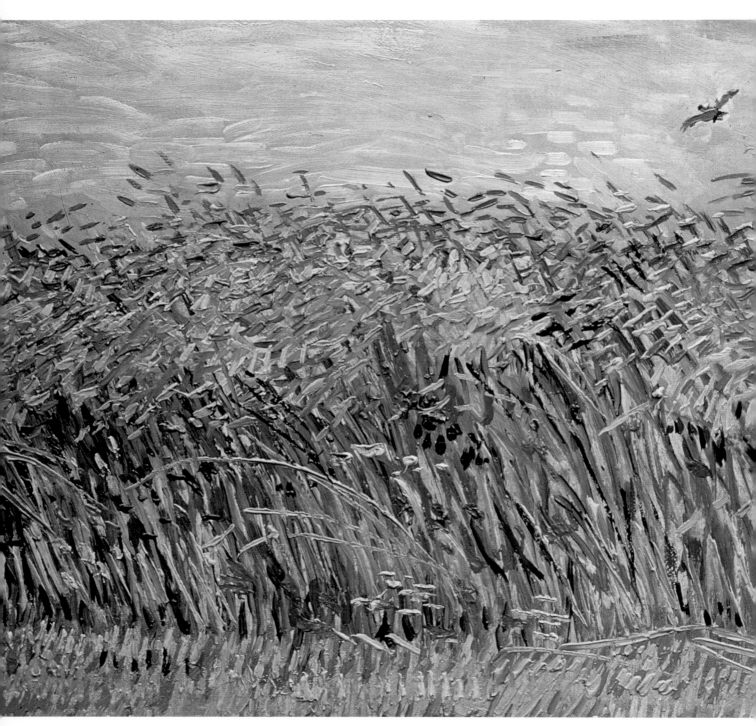

Wheatfield with a Lark, 1887
Oil on canvas, 54 x 65.5 cm (21 x 25⅞ in)
• Van Gogh Museum, Amsterdam

A lark flies up from a field of wheat. Directional brushstrokes capture the soft, early summer breeze. The light and plain composition show Van Gogh's abandonment of his earlier, darker palette, but his retention of thick paint.

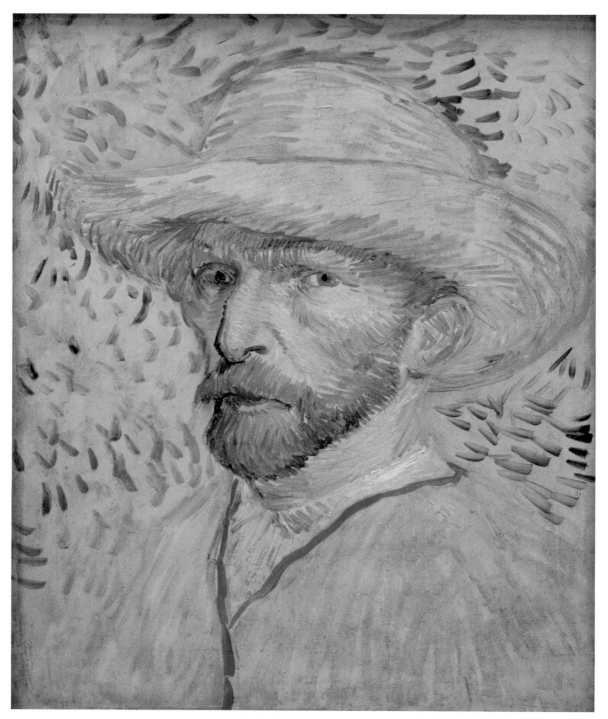

Self-Portrait with Straw Hat, 1887
Oil on cardboard, 40.5 x 32.5 cm (15⅚ x 12⅝ in)
• Van Gogh Museum, Amsterdam

While in Paris from 1886 to 1888, with no money for models, Van Gogh produced more than twenty self-portraits. He painted this one during the summer of 1887, experimenting with a new style of sketchy brushwork.

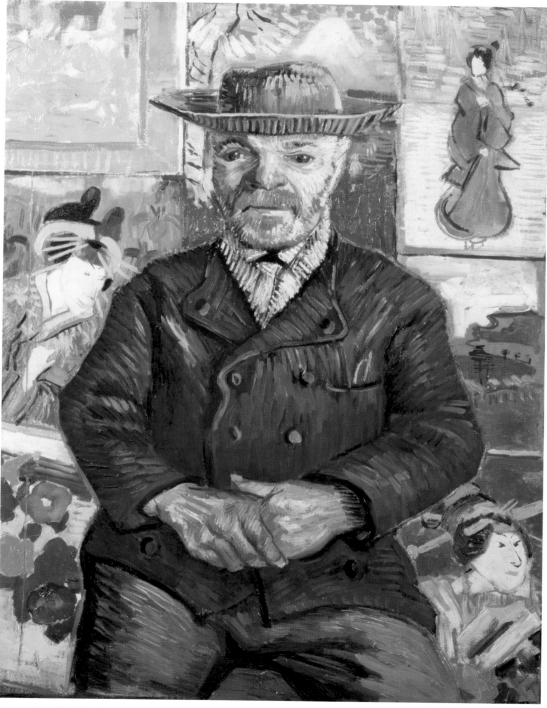

Portrait of Père Tanguy, 1887–88
Oil on canvas, 65 x 51 cm (24⅞ x 20 in)
• Private Collection

Art supplies seller Julien Tanguy fed impoverished local artists, accepting their paintings as payment. Van Gogh met Signac and Bernard in his shop, and also painted two portraits of Tanguy, set against this background of Japanese prints.

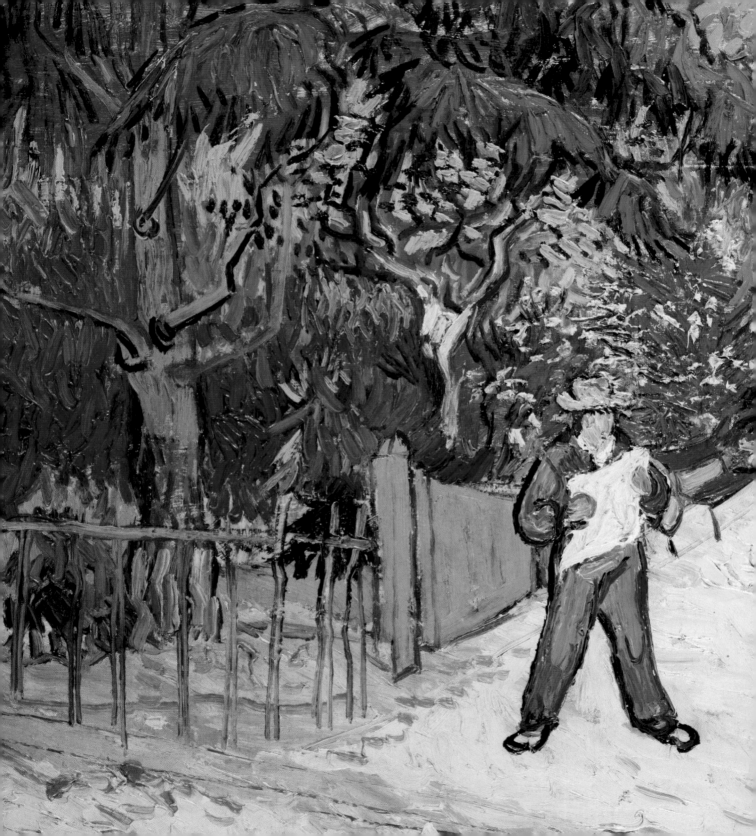

Arles

Planning on establishing an art
colony, Van Gogh moved to Arles
in 1888. Enchanted by the
landscape and light, his palette
brightened further, but while
there he suffered his first serious
bout of mental health problems.

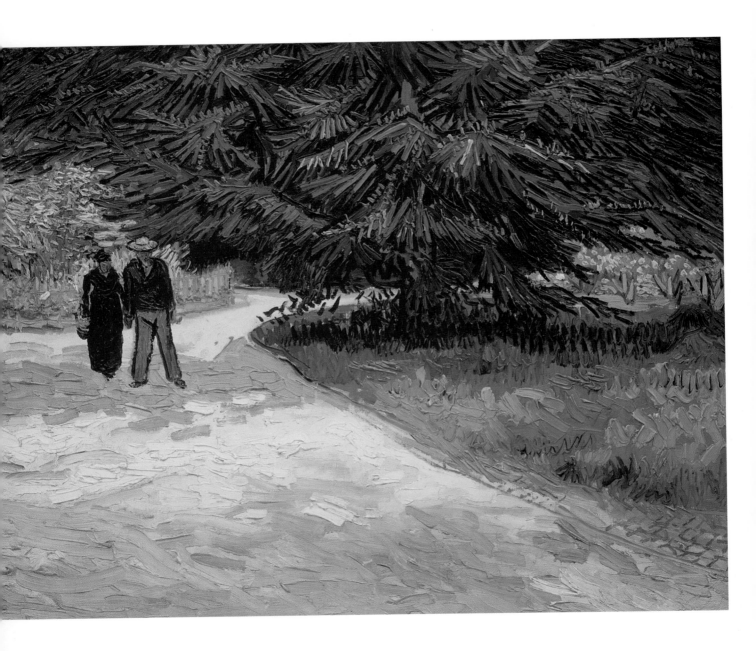

In the Public Gardens in Arles, 1888
Oil on canvas, 73 x 92 cm (28¾ x 36 in) • Private Collection

As soon as he arrived in Arles in summer 1888, Van Gogh began painting. This is one of a series of paintings from one location. Rich colours convey the dense foliage and intense light of the South of France.

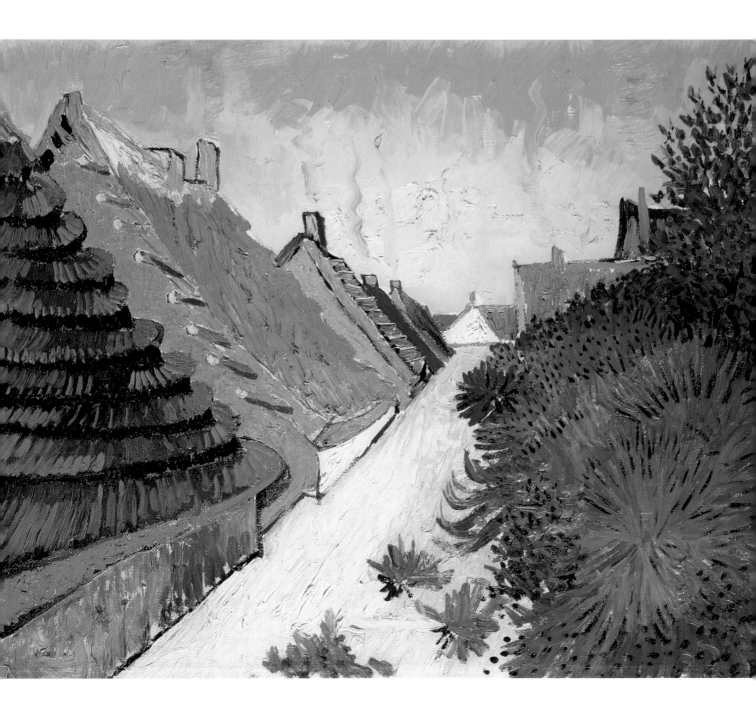

Farmhouses at Saintes-Maries, 1888
Oil on canvas, 38.3 x 46.1 cm (15 x 18 in)
• Private Collection

From Arles, Van Gogh travelled to the small fishing village of Saintes-Maries-de-la-Mer, where he painted this street with thatched-roof houses. The sky is built up with layers, while finer brushstrokes make up the foliage and buildings.

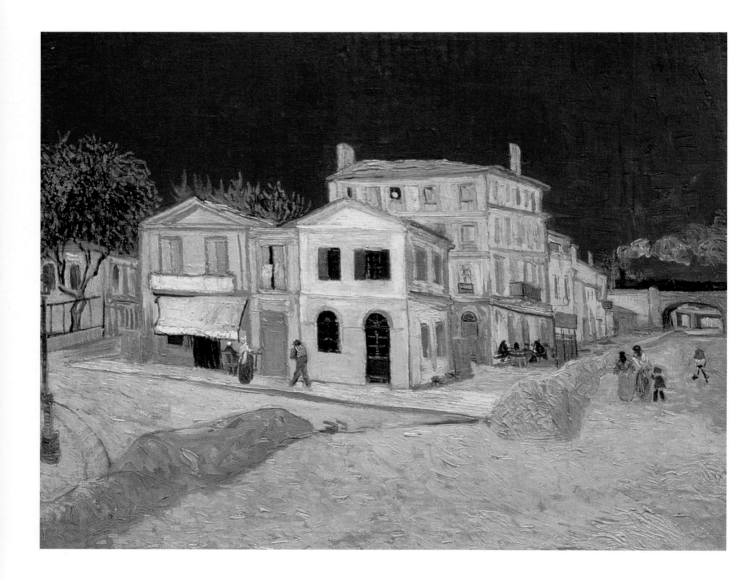

The Yellow House, Arles, 1888
Oil on canvas, 72 x 91.5 cm (28³/₁₀ x 36⅛ in)
• Van Gogh Museum, Amsterdam

In May 1888, Van Gogh rented four rooms in this house in Arles, with the green door and shutters. Next door was the restaurant where he ate his meals, while the street lamp and railway bridge imply modern developments.

La Mousmé, 1888
Oil on canvas, 73.3 x 60.3 cm (28⅞ x 23¾)
• National Gallery of Art, Washington, DC

A mousmé was a female character in a popular French novel set in Japan. Contrasting patterns and complementary colours are emphasized against the pale background, while the girl's face is painted in greater detail.

Garden at Arles, or, Flowering Garden with Path, 1888
Oil on canvas, 82.8 x 102 cm (32½ x 40 in)
• Gemeentemuseum Den Haag, The Hague

Mauve had encouraged Van Gogh to paint directly from nature, and this view of a sunlit garden, from a high viewpoint and resembling a colourful embroidery, continues to express that influence, while the colours derive from Impressionism.

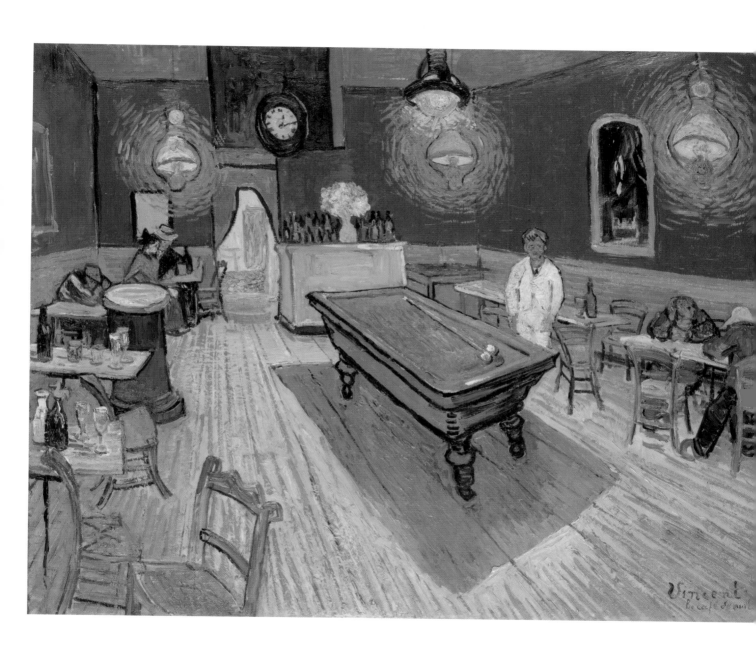

The Night Café, 1888
Oil on canvas, 72.4 x 92.1 cm (28½ x 36⅛ in)
• Yale University Art Gallery, New Haven

In a letter to Theo, Van Gogh described this painting of the Café de la Gare, where he lodged: 'I have tried to express the terrible passions of humanity by means of red and green. The room is blood red and dull yellow with a green billiard table in the centre, four lemon yellow lamps with an orange and green glow'.

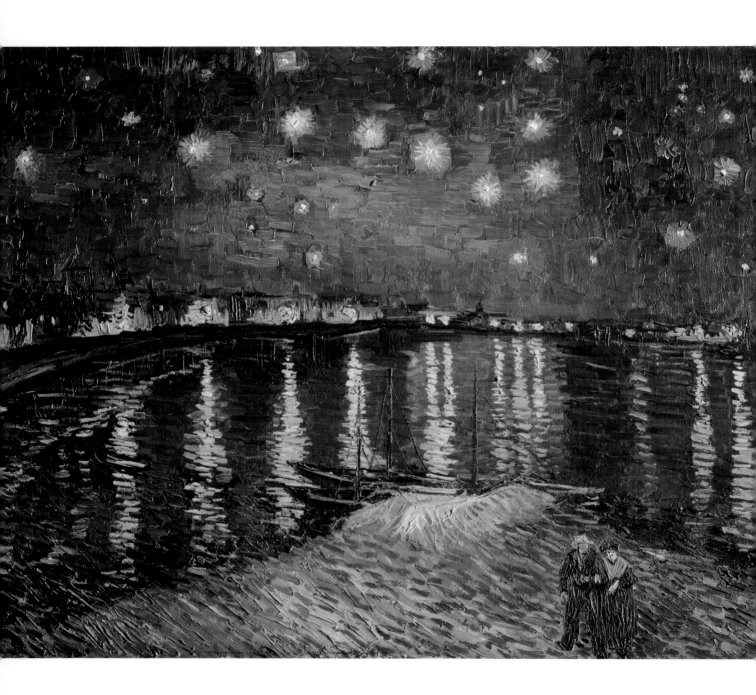

Starry Night over the Rhone, or, Starry Night, 1888
Oil on canvas, 72.5 x 92 cm (28½ x 36¼ in)
• Musée d'Orsay, Paris

In a letter to his sister Willemina, Van Gogh wrote: 'Often it seems to me night is even more richly coloured than day.' In this, his second night painting, the sky is Prussian blue, ultramarine and cobalt, with sparkling yellow gaslights and stars.

The Red Vineyard in Arles, 1888
Oil on canvas, 75 x 93 cm (29½ x 36⅔ in)
• The Pushkin Museum of Fine Arts, Moscow

There is a long-held belief that this was the only painting Van Gogh sold during his lifetime, but it has not been verified. It was one of the few paintings he completed from memory rather than from direct observation.

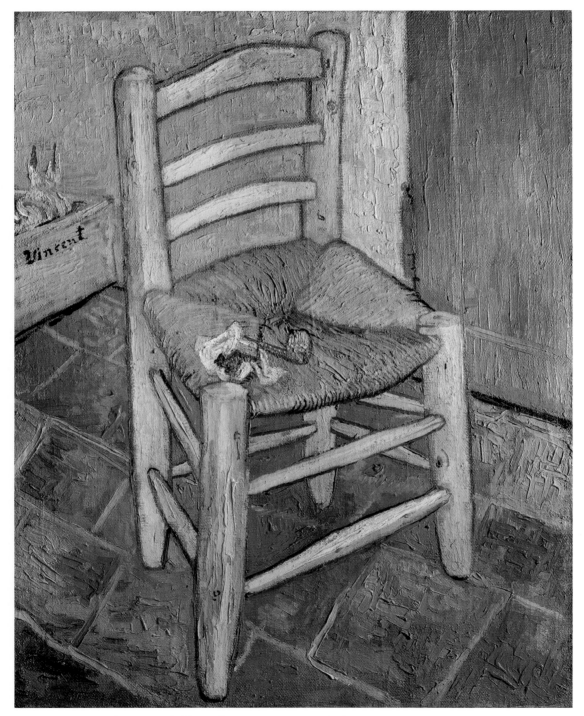

Van Gogh's Chair, 1888
Oil on canvas, 91.8 x 73 cm (36 x 28¾ in)
• The National Gallery, London

This simple chair on a red-tiled floor with a pipe, handkerchief and tobacco seems to represent Van Gogh's perception of himself. Yellow helped to lift his spirits. The chair can also be seen in *The Bedroom* (*see* page 79).

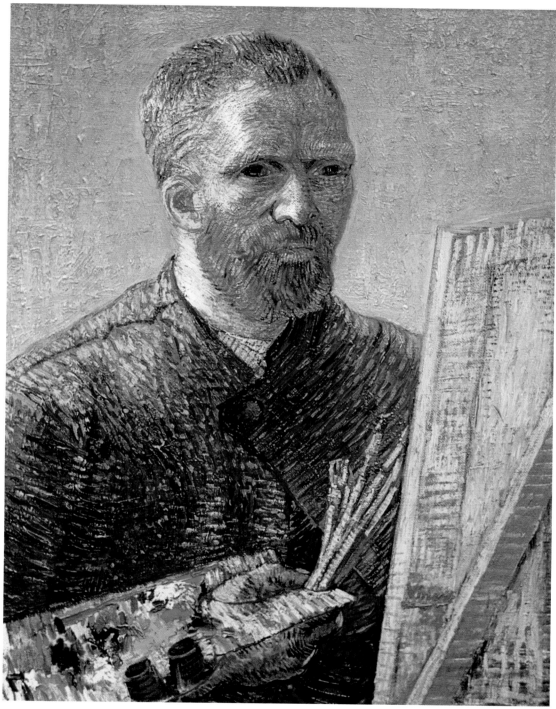

Self-Portrait as a Painter, 1888
Oil on canvas, 65.5 x 50.5 cm (25¾ x 19⅞ in)
• Van Gogh Museum, Amsterdam

In one of the few self-portraits in which Van Gogh portrayed himself as an artist, he holds his palette and brushes in front of a canvas on an easel. Contrasting colours and directional brushstrokes enliven the static composition.

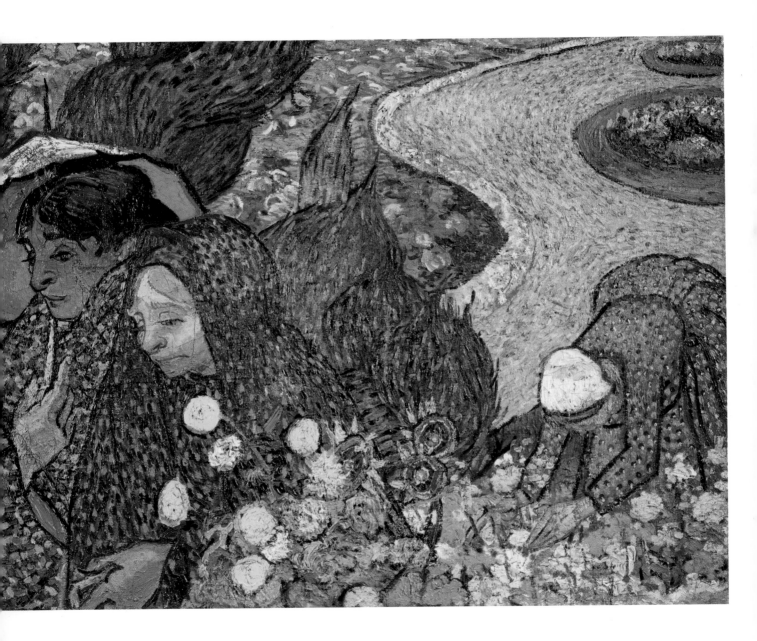

Memory of the Garden at Etten (Ladies of Arles), 1888
Oil on canvas, 73 x 92 cm (28¾ x 36 in) • The State Hermitage
Museum, St Petersburg

Painted in November 1888, while Gauguin was staying with him in Arles, Van Gogh showed his efforts to follow his friend's advice to paint more from his imagination and less from what he saw directly before him.

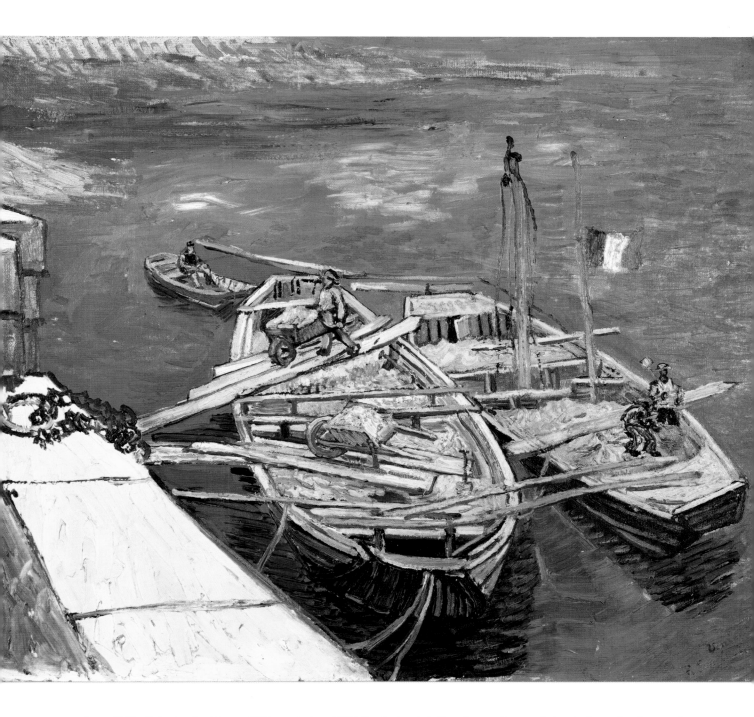

Quay with Men Unloading Sand Barges, 1888
Oil on canvas, 55.1 x 66.2 cm (21⅗ x 26⅗ in)
• Folkwang Museum, Essen

In August 1888, Van Gogh wrote to Theo: 'I am working on a study … boats seen from the quay above … pink tinged with violet, the water is bright green, no sky, a tricolour on the mast. A workman with a barrow is unloading sand.'

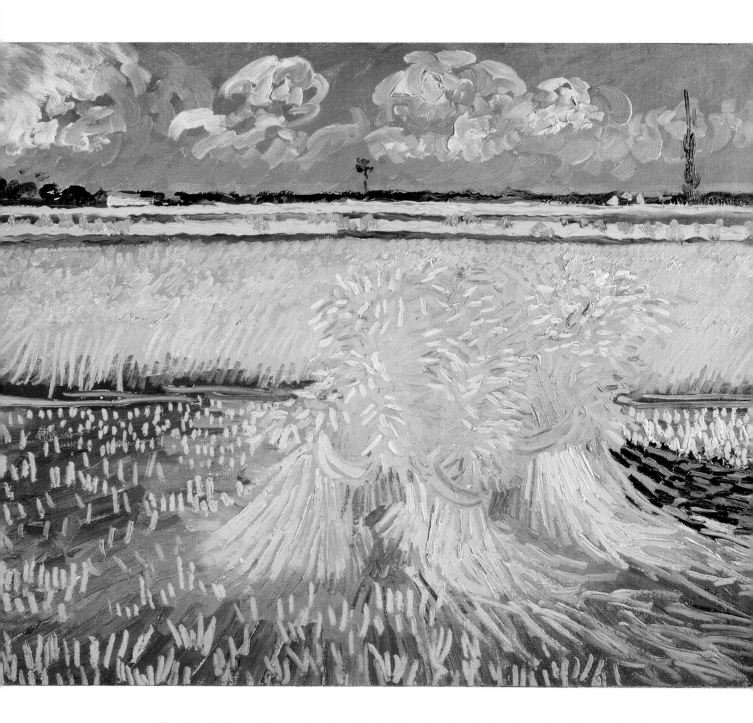

Wheatfield with Sheaves, 1888
Oil on canvas, 55.2 x 66.7 cm (21¾ x 26¼ in)
• Honolulu Museum of Art, Honolulu

Impasto paint and brightly coloured brushmarks make up this painting, one of Van Gogh's ten paintings of 'The Harvest' that he produced in the last half of June 1888. Although an objective theme, his rendering is subjective.

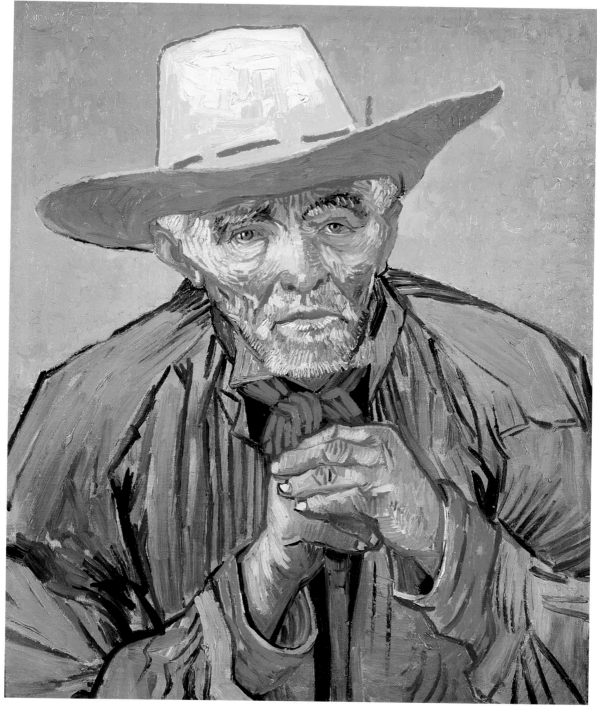

Portrait of a Peasant (Patience Escalier), 1888
Oil on canvas, 69.2 x 56 cm (27¼ x 22 in)
• Private Collection

Van Gogh wrote to Theo stating that he was returning to ideas he had before he went to Paris, suggesting that he was evolving a new style. His use of colour is certainly unlike any other art being produced at the time.

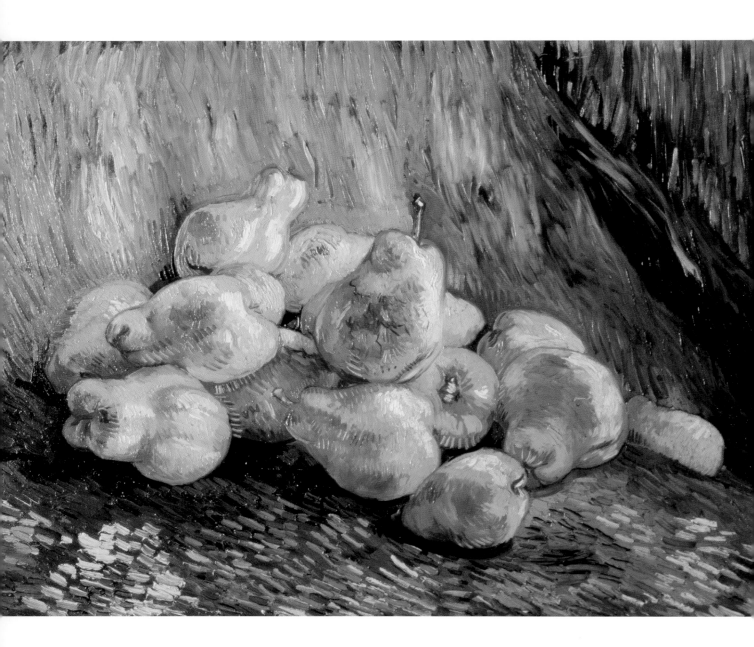

Still Life with Quinces, or, Still Life with Pears, 1888
Oil on canvas, 46 x 59.5 cm (18 x 23¼ in)
• Galerie Neue Meister, Dresden

Van Gogh had frequently painted still lifes, using them to express various ideas and to experiment. This was predominantly painted as a study of complementary colours: yellow-orange with a deep turquoise-blue.

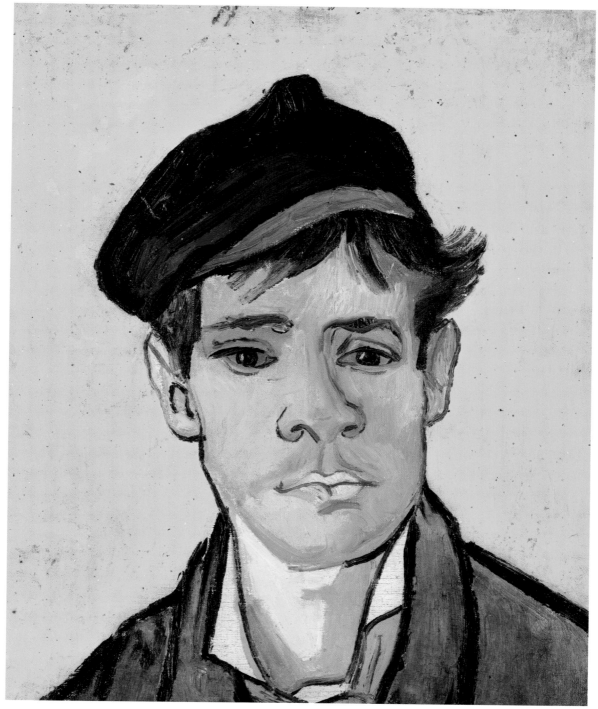

Young Man with a Cap (Armand Roulin), 1888
Oil on canvas, 47 x 39 cm (18½ x 15¼ in)
• Private Collection

In Arles, Van Gogh painted portraits of his friend the postmaster Joseph Roulin, his wife Augustine and their three children: Armand, Camille and Marcelle. Serious-looking Armand was seventeen here and a blacksmith's apprentice.

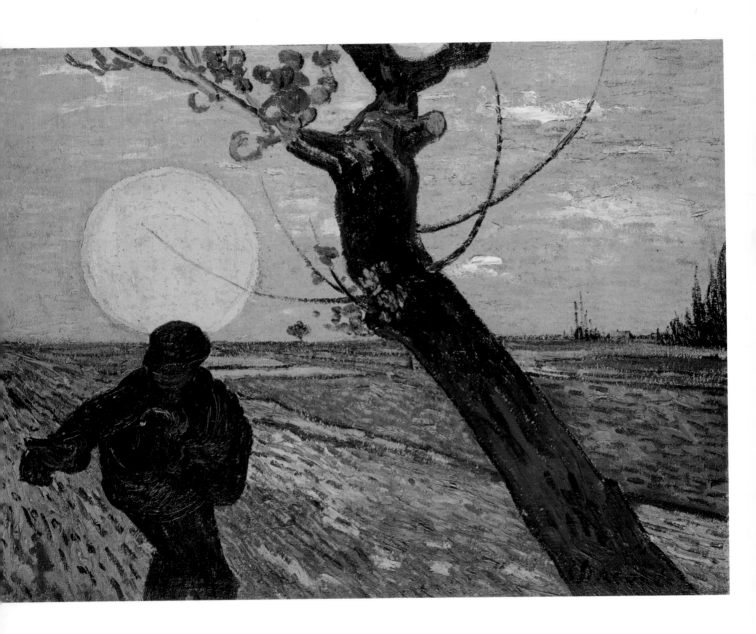

Sower with Setting Sun, 1888
Oil on canvas, 73 x 92 cm (28¾ x 36¼ in)
• Foundation E.G. Bührle Collection, Zürich

Van Gogh painted a number of variations on the theme of sowers and reapers, and more specifically two versions of this striking composition. The design and bright colours may have been inspired by Japanese prints.

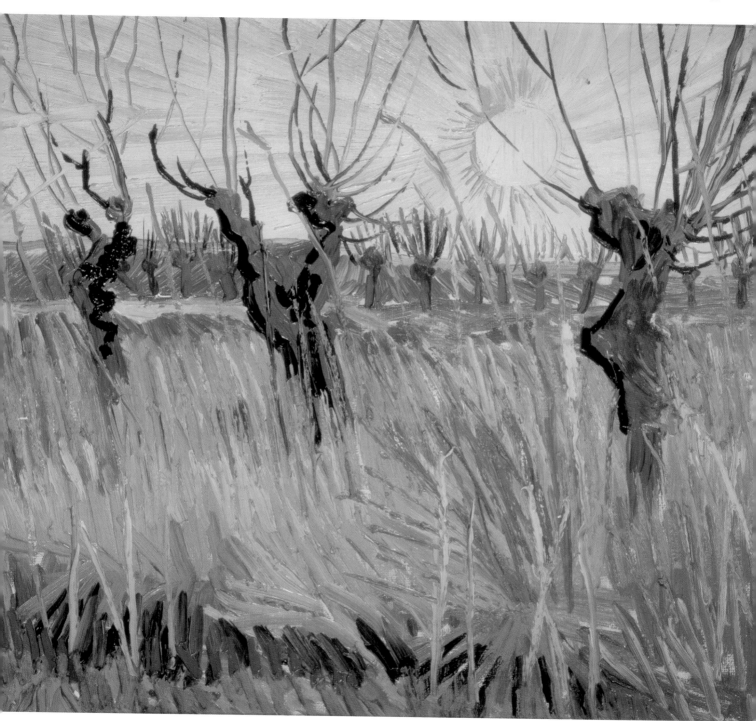

Pollarded Willows at Sunset, 1888
Oil on canvas mounted on cardboard, 31.5 x 34.5 cm (12¼ x 13½ in)
• Rijksmuseum Kroller-Muller, Otterlo

When he was in Nuenen, Van Gogh had painted and drawn several pollarded trees, and still fascinated by their gnarled contours, he painted these similar trees in Arles in March 1888, interpreting them with his new, expressive colours.

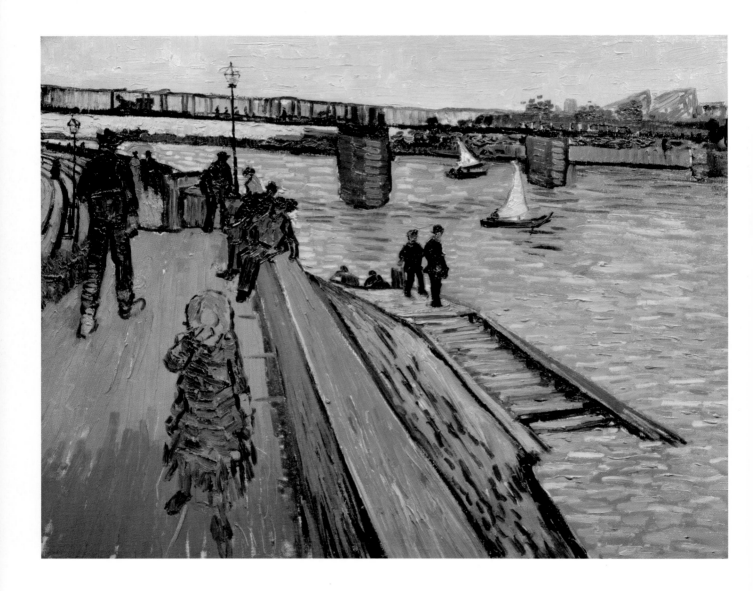

The Trinquetaille Bridge, 1888
Oil on canvas, 65 x 81 cm (25½ x 31¾ in)
• Private Collection

In April 1888, Van Gogh drew an ink drawing of the Trinquetaille Bridge from a distance. He painted this in June and another painting of the same location in October, sending this canvas to Theo in Paris in August 1888.

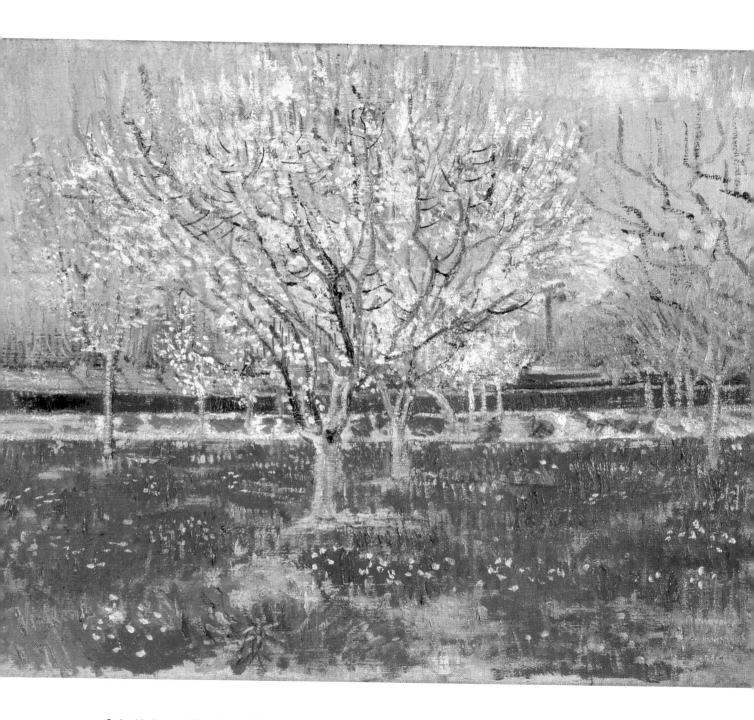

Orchard in Blossom (Plum Trees), 1888
Oil on canvas, 54 x 65.2 cm (21¼ x 25⅔ in)
• Scottish National Gallery, Edinburgh

In one of several paintings of the plum trees of Arles, Van Gogh created a light and balanced composition, his brushmarks describing the differences between solid branches and trunks, and delicate spring blossoms.

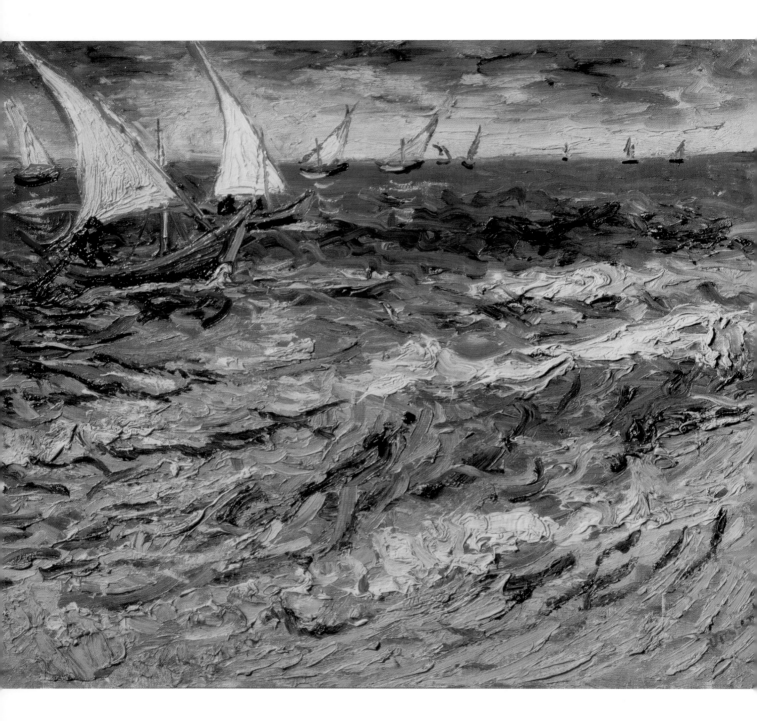

**Seascape at Saintes-Maries
(View of the Mediterranean), 1888**
Oil on canvas, 44.5 x 54.5 cm (17½ x 21½ in)
• The Pushkin Museum of Fine Arts, Moscow

In June 1888, Van Gogh spent a week in the village of Saintes-Maries-de-la-Mer, not far from Arles. He wrote to Theo: 'The Mediterranean Sea is a mackerel colour … changeable – you do not always know whether it is green or purple….'

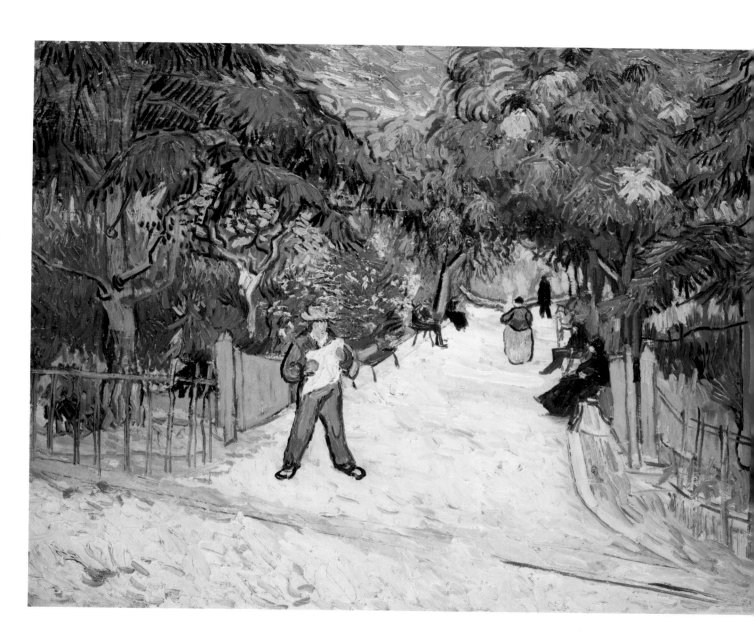

Entrance to the Public Park in Arles, 1888
Oil on canvas, 72 x 91 cm (28½ x 35¾ in)
• Phillips Collection, Washington, DC

One of a series produced in Arles between August and October 1888, the bright light, vivid colours and dense foliage express Van Gogh's enthusiasm. He wrote of the area: 'It absorbs me so much that I let myself go.'

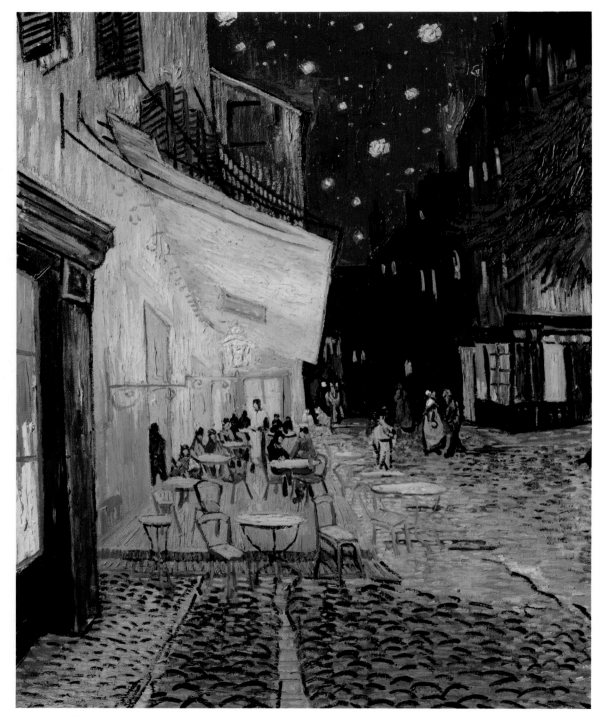

**The Café Terrace on the Place du Forum,
Arles, at Night, 1888** • Oil on canvas,
81 x 65.5 cm (31⅞ x 25¾ in) • Museum Kröller-Müller, Otterlo

In September, after spending August painting sunlit fields, Van Gogh painted this and described it in a letter: 'the terrace of a café at night, lit up by a big gas lantern, with a patch of blue star-filled sky'.

The Bridge at Trinquetaille, 1888
Oil on canvas, 72.5 x 91.5 cm (28½ x 36 in)
• Private Collection

Painted during the fifteen months that Van Gogh spent at Arles, this bridge connects Arles with the suburb of Trinquetaille on the opposite bank of the River Rhone. He drew and painted it on several occasions from different viewpoints.

The Schoolboy (Camille Roulin), 1888
Oil on canvas, 63 x 54 cm (24⅞ x 21¼ in)
• Museu de Arte de São Paulo, São Paulo

Camille, the middle child of the Roulin family, was eleven when Van Gogh painted this portrait of him in December 1888. Set against a contrasting background, the boy is clearly reluctant to be sitting there, and is fidgeting.

L'Arlésienne: Madame Joseph-Michel Ginoux, 1888–89

Oil on canvas, 91.4 x 73.7 cm (36 x 29 in)

• Metropolitan Museum of Art, New York

This is the second of two portraits that Van Gogh painted of Marie Ginoux, the owner of the Café de la Gare in Arles. She befriended Van Gogh when he arrived in Arles and looked after him when he was ill.

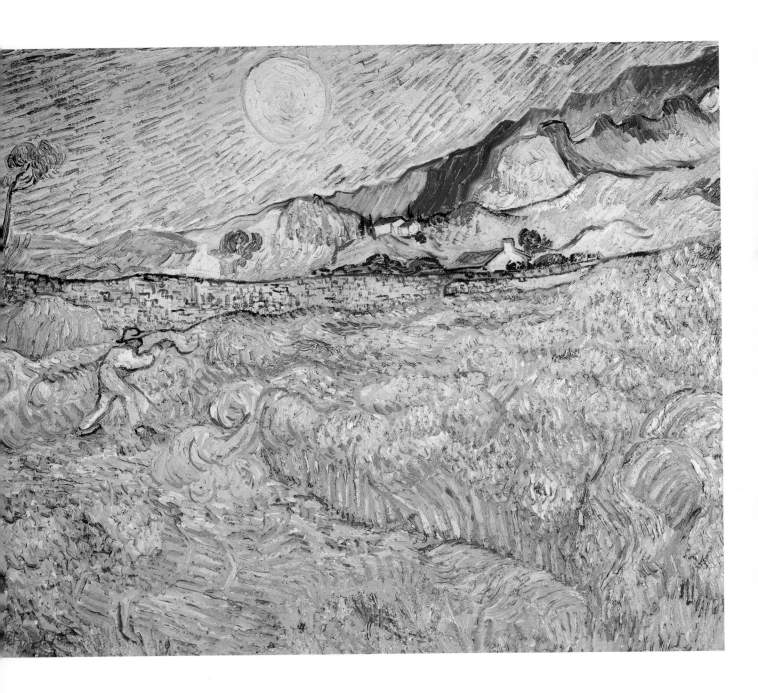

Wheatfield with a Reaper, 1889
Oil on canvas, 73 x 92 cm (28¾ x 36 in)
• Van Gogh Museum, Amsterdam

From his window in the asylum in Saint-Rémy, where he stayed during the spring of 1889, Van Gogh saw this reaper in a sunny wheat field. While in hospital, he drew and painted a lot to alleviate his depression.

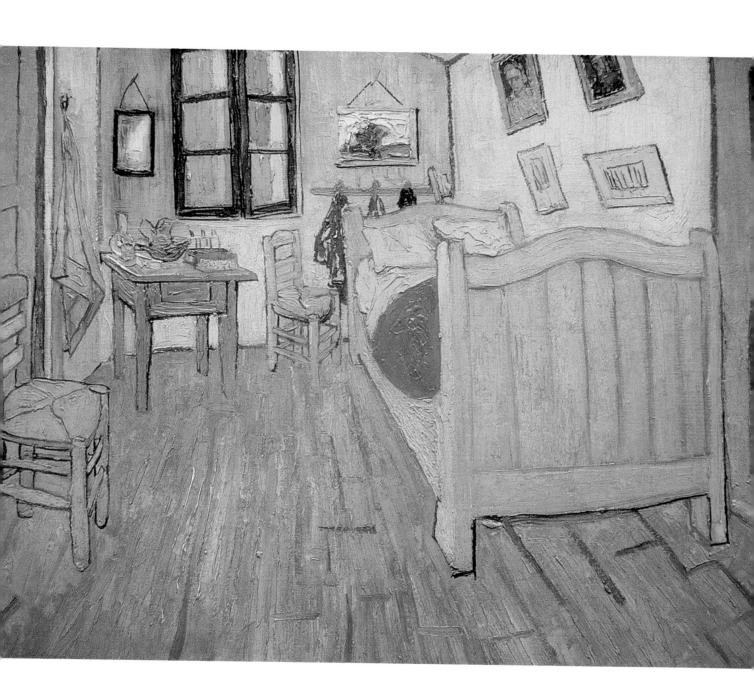

Van Gogh's Bedroom at Arles, or, The Bedroom 1889
Oil on canvas, 57.5 x 74 cm (22⅔ x 29 in)
• Musée d'Orsay, Paris

Van Gogh painted three similar paintings of his bedroom in the Yellow House at Arles, aiming to express its tranquillity through colour. Several pairs of objects also suggest the hope he felt in anticipation of Gauguin's arrival.

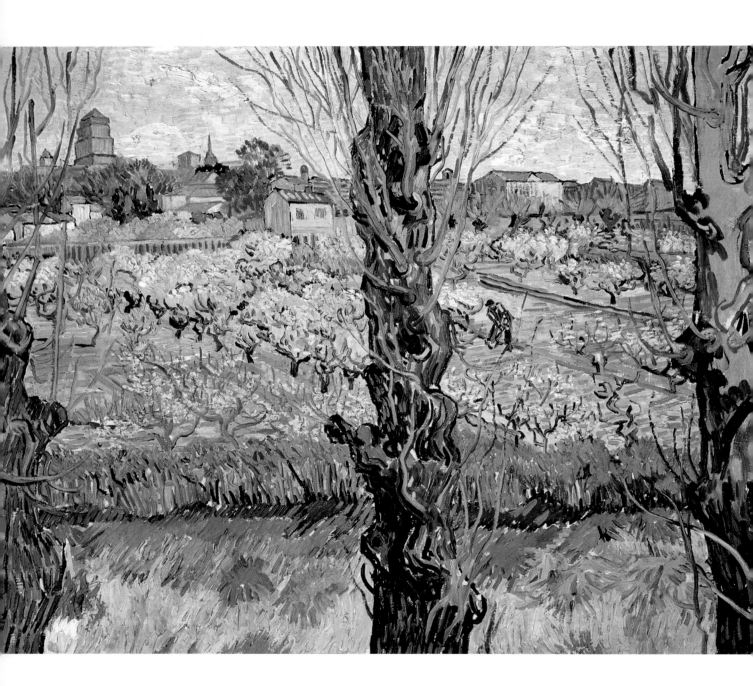

View of Arles, 1889
Oil on canvas, 72 x 92 cm (28¼ x 36¼ in)
• Neue Pinakothek, Munich

The light colours and directional marks reflect Van Gogh's impression of springtime in Arles. The composition, however, reveals his inner worries, as twisted dark forms loom like barriers in front of the world beyond.

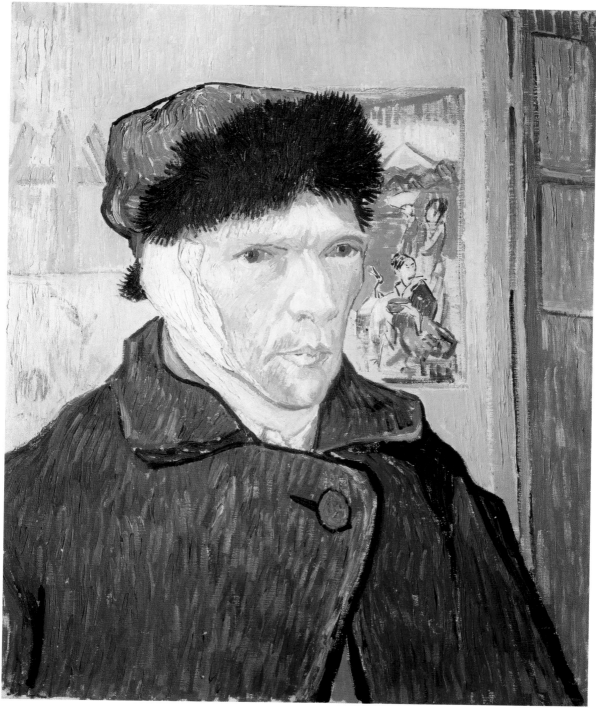

Self-Portrait with a Bandaged Ear, 1889
Oil on canvas, 60.5 x 50 cm (23¾ x 19⅝ in)
• The Courtauld Gallery, London

Completed two weeks after the altercation with Gauguin, this self-portrait announces Van Gogh's determination to continue painting. He sits between an easel and a Japanese print. The bandage appears on his right ear as he painted from a mirror.

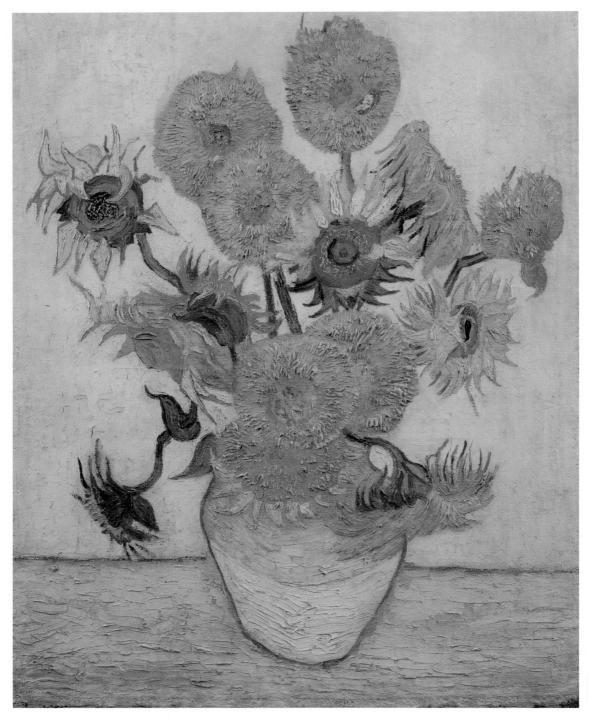

Vase with Fifteen Sunflowers, 1889
Oil on canvas, 100.5 x 76.5 cm (39½ x 30 in) • Seiji Togo Memorial
Sompo Japan Museum of Art, Tokyo

In January 1889, Van Gogh returned to his sunflowers briefly. He wrote to Theo: '... You must have noticed in Gauguin's room the two canvases of the sunflowers. I've just put the finishing touches to the absolutely equivalent and identical repetitions.'

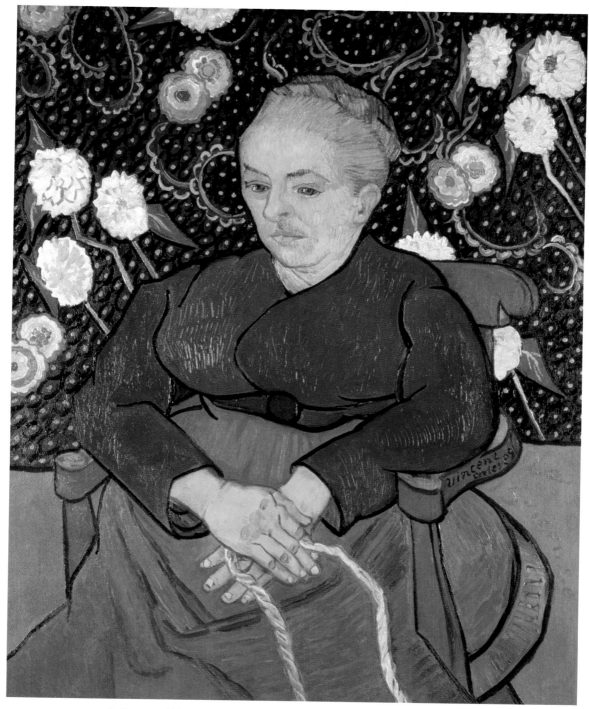

La Berceuse, 1889
Oil on canvas, 92.7 x 73.7 cm (36½ x 29 in)
• Metropolitan Museum of Art, New York

Van Gogh painted five portraits of Augustine Roulin, wife of his friend Joseph. 'La Berceuse' means 'lullaby', or 'woman who rocks the cradle', and the rope in her hand is attached to a cradle she is rocking – beyond the picture.

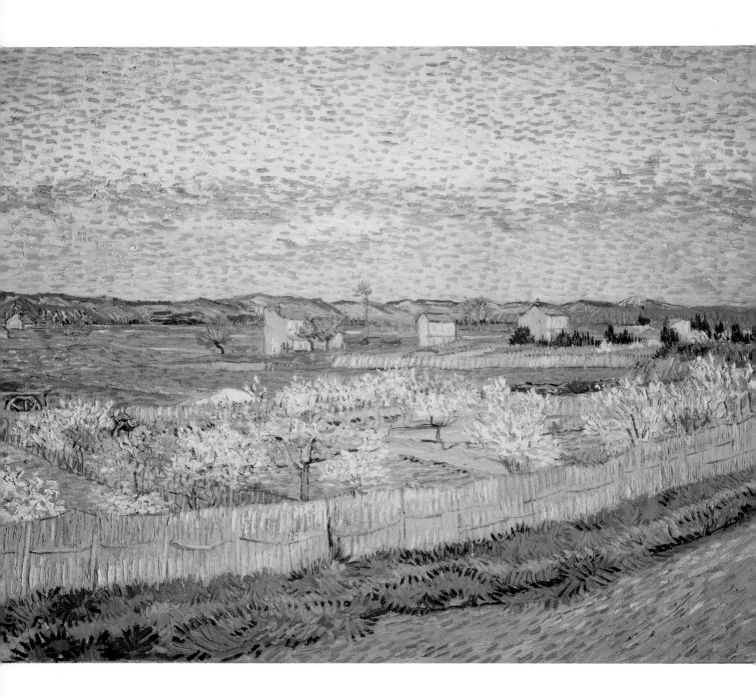

**Peach Trees in Blossom, or, The Plain of
La Crau with an Orchard, 1889**
Oil on canvas, 65 x 81 cm (25½ x 31⅞ in)
• The Courtauld Gallery, London

Between Arles and the ruined monastery of Montmajour, Van Gogh often described La Crau in letters,
saying that it reminded him of seventeenth-century Dutch landscape paintings, but his colours expressed
a livelier, contemporary approach.

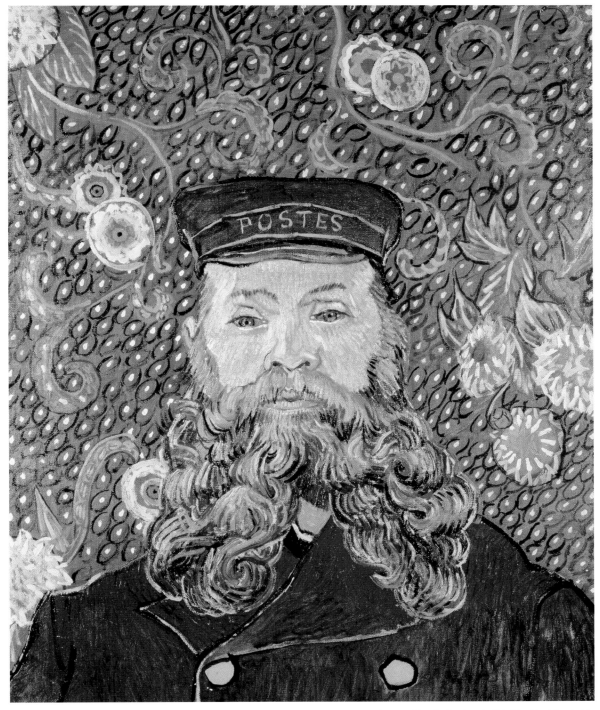

Portrait of the Postman Joseph Roulin, 1889
Oil on canvas, 64.4 x 55.2 cm (25⅜ x 21⁷⁄₁₀ in)
• Museum of Modern Art, New York

This portrait of Joseph Roulin is one of six that Van Gogh painted of his friend in Arles. In his characteristic uniform, Roulin sits before a bold background. Van Gogh described this to Theo as a 'modern portrait'.

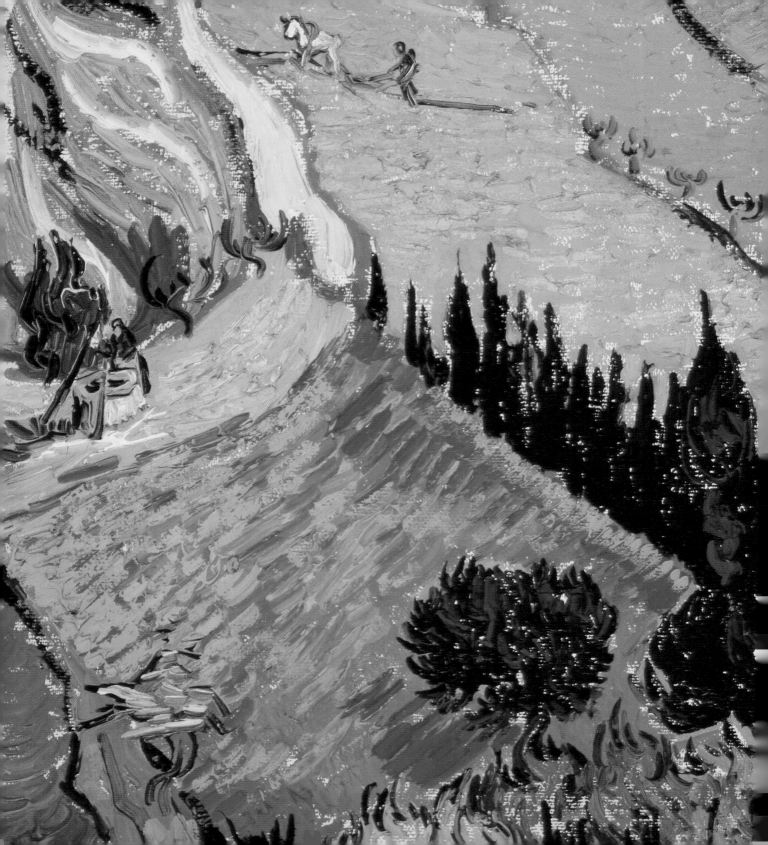

Saint-Rémy

On 8 May 1889, Van Gogh admitted himself to a Saint-Rémy asylum for a year, where he produced many drawings and paintings of the hospital gardens, local landscapes and portraits.

Pietà, 1889
Oil on canvas, 73 x 60.5 cm (28¾ x 23⅞ in)
• Van Gogh Museum, Amsterdam

During his time staying at the asylum in Saint-Rémy, Van Gogh painted this image of the Virgin Mary mourning over the dead Christ, based on a lithograph he had seen after a painting by Eugène Delacroix (1798–1863).

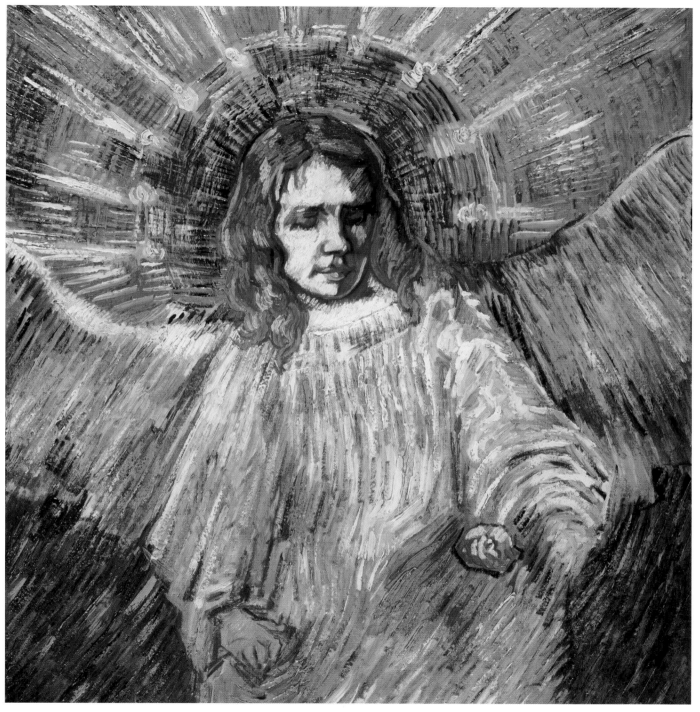

Half Figure of an Angel (after Rembrandt), 1889
Oil on canvas, 54 x 64 cm (21¼ x 25 in)
• Private Collection

The current location of this painting is unknown. With his close links to Christianity, Van Gogh copied several angel paintings by Rembrandt, interpreting them in his own expressive style and vibrant palette.

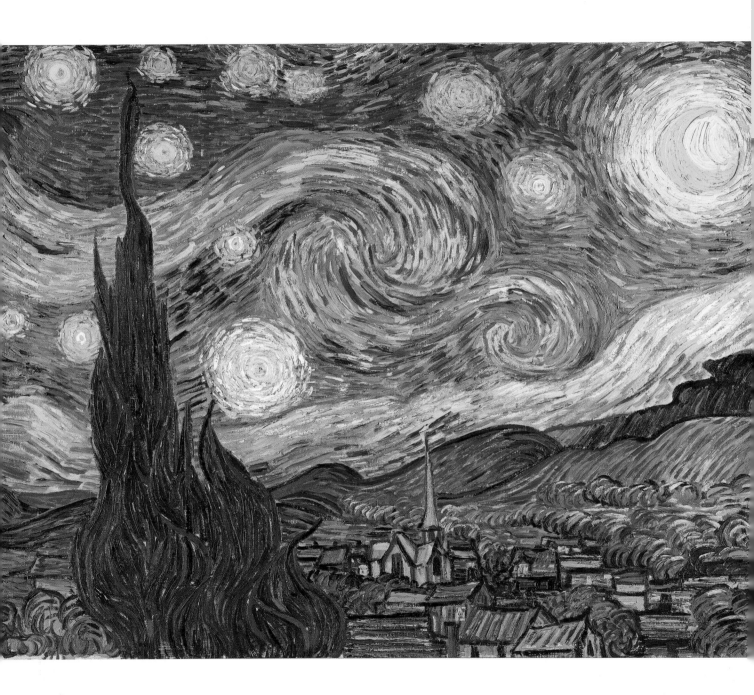

The Starry Night, 1889
Oil on canvas, 73.7 x 92.1 cm (29 x 36¼ in)
• Museum of Modern Art, New York

Expressing both Van Gogh's anxieties and religious feelings, a solitary, dark cypress tree rises above a village with a tall church steeple. Clouds, stars and a bright crescent moon swirl across the seemingly omnipotent night sky.

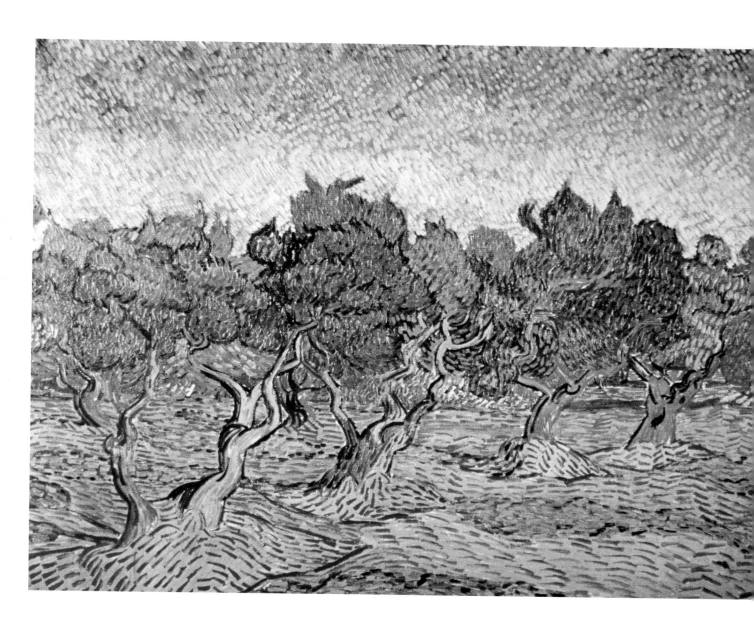

Olive Grove, 1889
Oil on canvas, 73 x 92 cm (29 x 36¼ in)
• Van Gogh Museum, Amsterdam

Although they did not grow in Arles, olive trees grew in the dry, rocky soil of Saint-Rémy. During his year at the asylum, Van Gogh made several paintings of them, focusing on their gnarled trunks and changing colours.

Portrait of Dr Felix Rey, 1889
Oil on canvas, 64 x 53 cm (25 x 20⅞ in)
• Pushkin Museum of Fine Arts, Moscow

Twenty-three year old Dr Felix Rey cared for Van Gogh at Saint-Rémy, and Vincent gave him this portrait as a gift. Unappreciative of the bold, expressive style of the painting, Rey used it to repair a hole in his chicken coop.

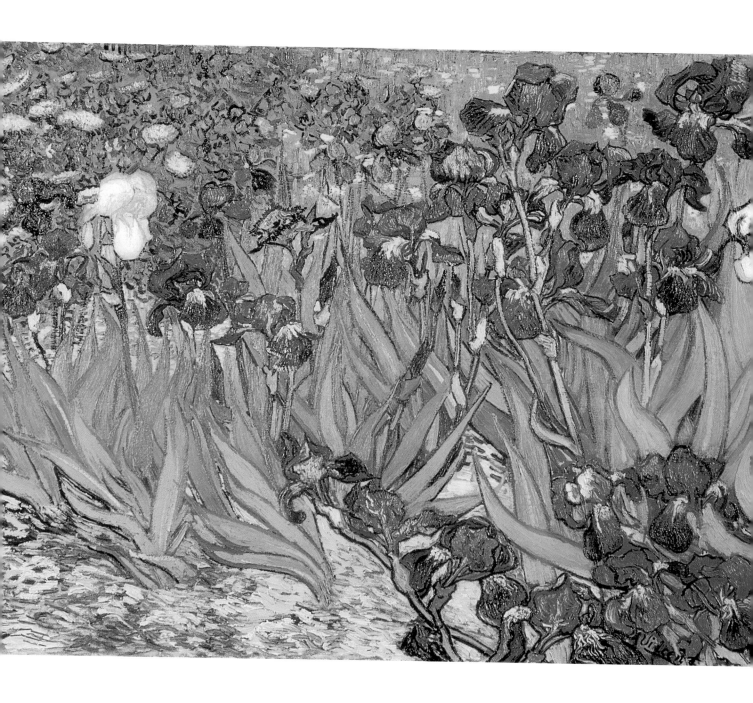

Irises, 1889
Oil on canvas, 71 x 93 cm (28 x 36⅔ in)
• J. Paul Getty Museum, Los Angeles

Through expressive colours and marks, Van Gogh sought to portray underlying identities. He painted this during his first week at the asylum. The deep blue and one white flower were inspired by his surroundings and by Japanese art.

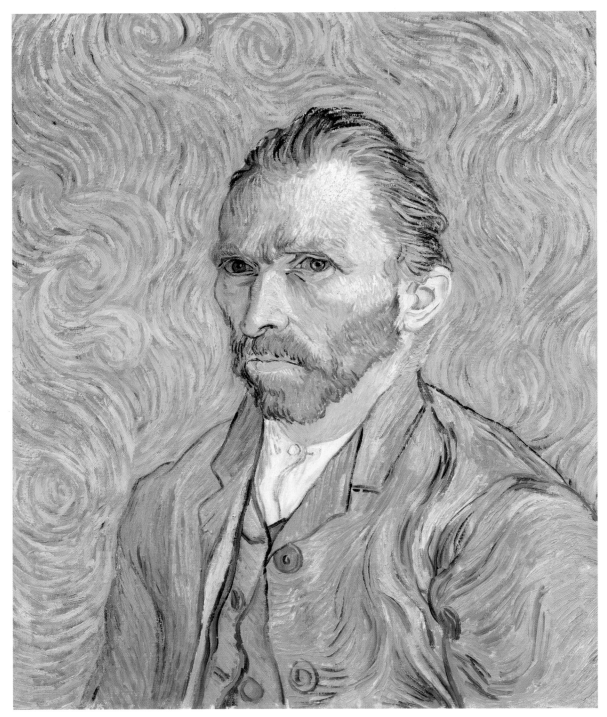

Self-Portrait, 1889
Oil on canvas, 65 x 54.5 cm (25½ x 21½ in)
• Musée d'Orsay, Paris

His penultimate and one of the most revealing of Van Gogh's self-portraits, this was painted in September. His introverted gaze displays his anxiety, while the soft green and turquoise contrast with his bright orange beard and hair.

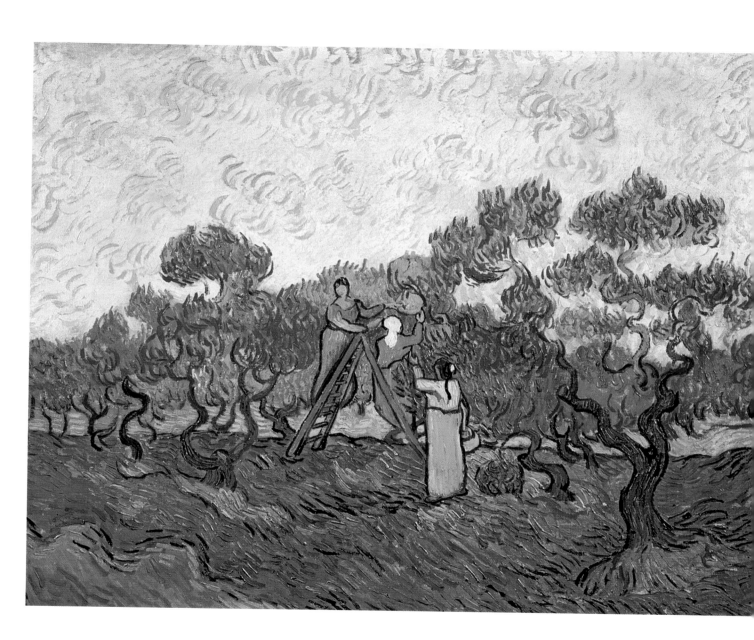

Women Picking Olives, 1889
Oil on canvas, 72.7 x 91.4 cm (28⅝ x 36 in)
• Metropolitan Museum of Art, New York

At the end of 1889, while still in the Saint-Rémy asylum, Van Gogh painted three versions of this picture, using his comma-like brushmarks, which reflected his own unique approach and an influence of the fashionable Art Nouveau style.

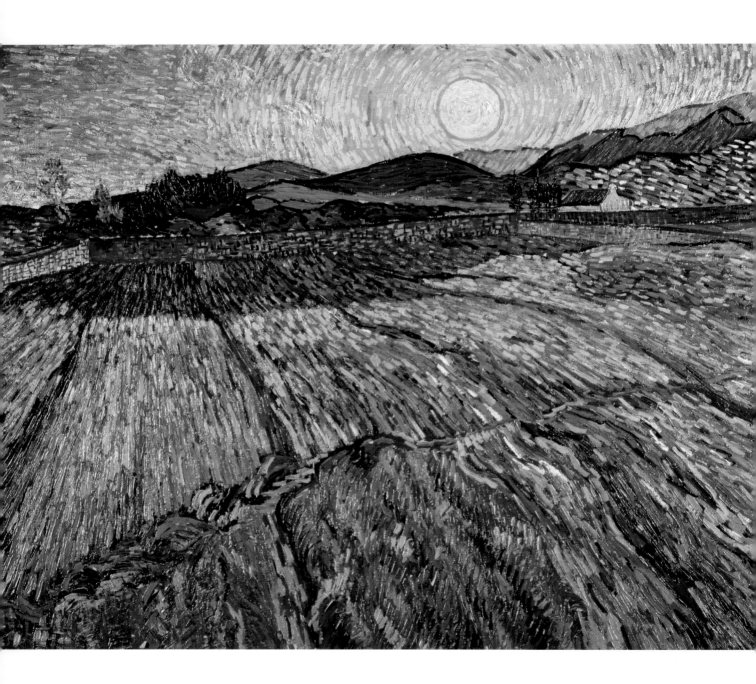

Enclosed Field with Rising Sun, 1889
Oil on canvas, 71 x 90.5 cm (28 x 35⅝ in)
• Private Collection

One of the six paintings that Van Gogh exhibited at the Les Vingt (Les XX) exhibition in Brussels in 1890, this was painted during November and December and represents the energy of life, as well as expressing 'calmness, great peace'.

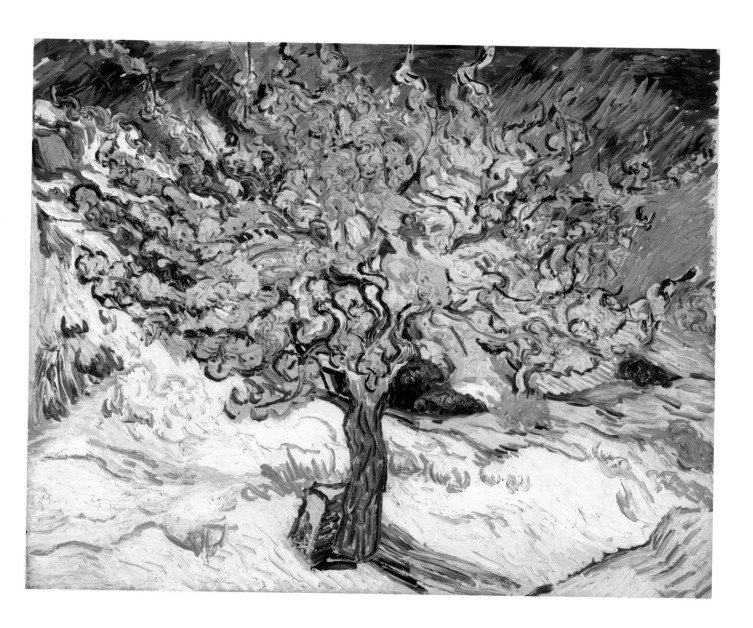

Mulberry Tree, 1889
Oil on canvas, 54 x 65 cm (21 x 25½ in)
• Norton Simon Collection, Pasadena

While in the Saint-Rémy asylum, Van Gogh painted vigorously in the surrounding vicinity. He wrote of this work to Theo and Willemina, believing it to be the best of his numerous mulberry tree paintings.

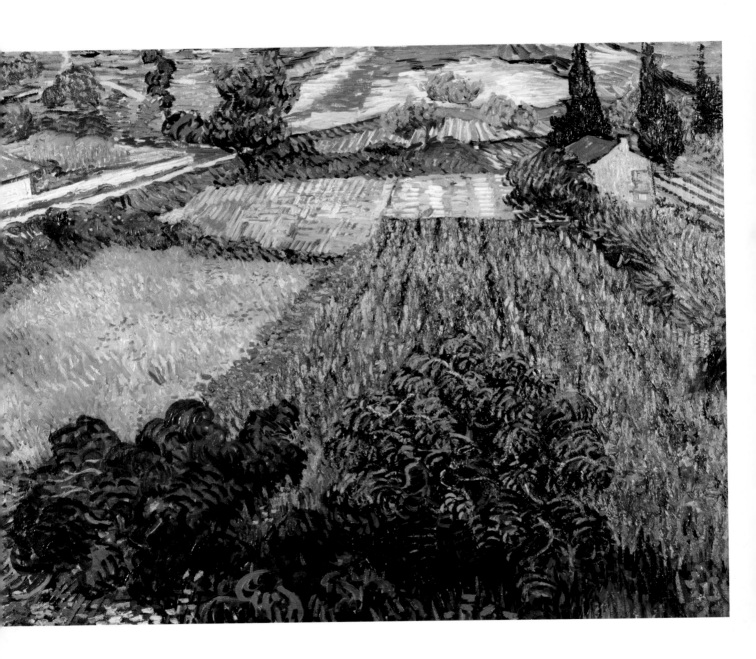

Field with Poppies, 1889
Oil on canvas, 71 x 91 cm (28 x 36 in)
• Kunsthalle, Bremen

One of the first pictures Van Gogh painted in 1889 when he arrived at Saint-Rémy, this controlled work with animated colour contrasts, brushstrokes and perspective reveal how astute he was between epileptic attacks.

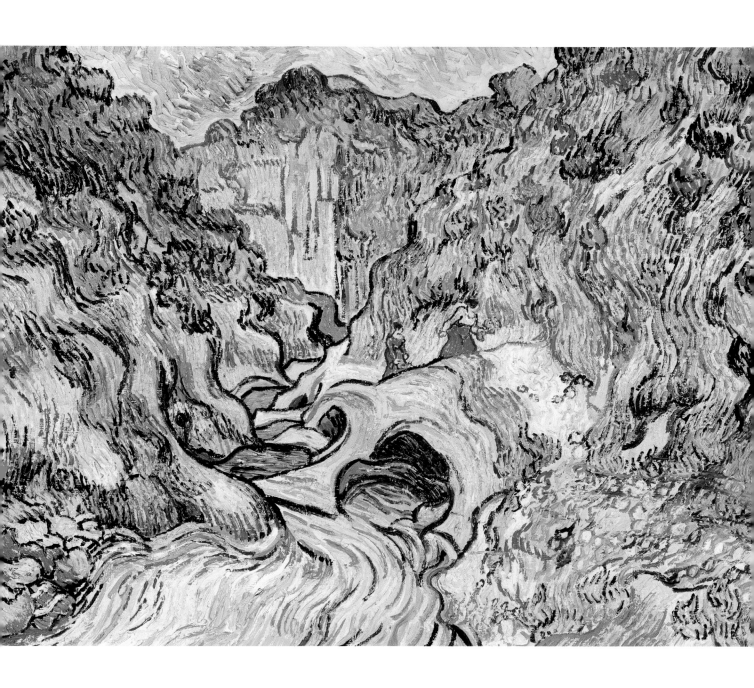

The Ravine (Les Peiroulets), 1889
Oil on canvas, 72 x 92 cm (28½ x 36¼ in)
• Rijksmuseum Kroller-Muller, Otterlo

These low-lying, rocky formations with ravines and rivulets were near to Saint-Rémy where Van Gogh was staying. The shapes and colours offered him the perfect subject in which to develop a more sinuous style.

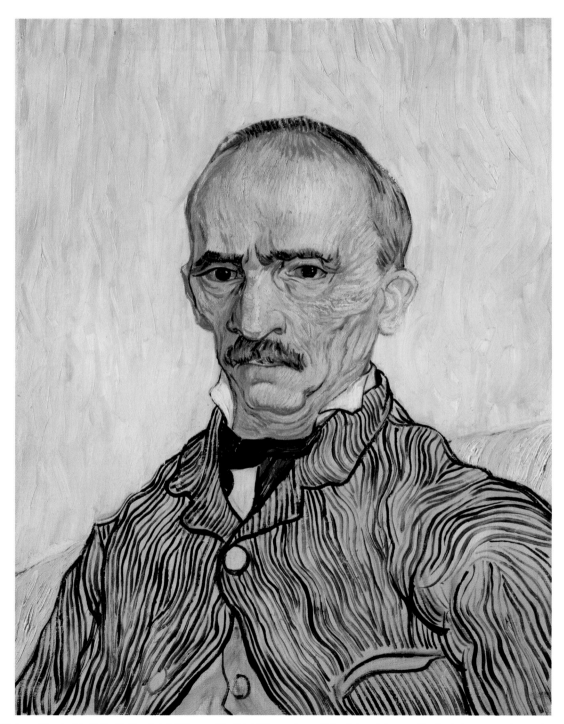

Portrait of Trabuc, Attendant in St Paul's Hospital, 1889
Oil on canvas, 61 x 46 cm (24 x 18 in)
• Kunstmuseum Solothurn, Solothurn

The Saint-Rémy asylum – St Paul's hospital – gave Van Gogh the opportunity to paint portraits. This is Trabuc, the hospital attendant. Powerful brushstrokes describe his personality, balanced against a delicately textured background.

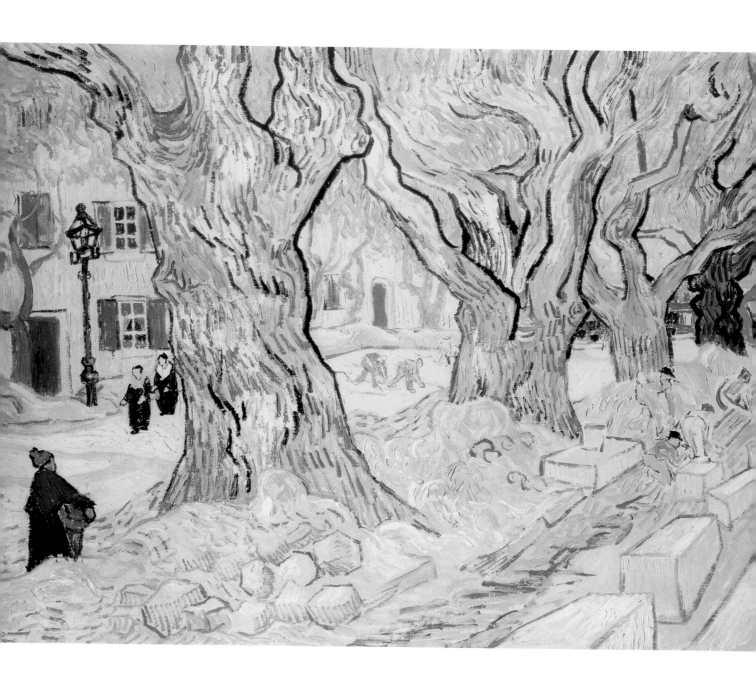

The Road Menders, 1889
Oil on canvas, 73.6 x 92.7 cm (29 x 36½ in)
• The Phillips Collection, Washington, DC

Van Gogh produced two versions of this work. The first was painted directly before the scene, while this was created later in his studio. A Saint-Rémy street is being repaved, but Van Gogh focused on the enormous plane trees.

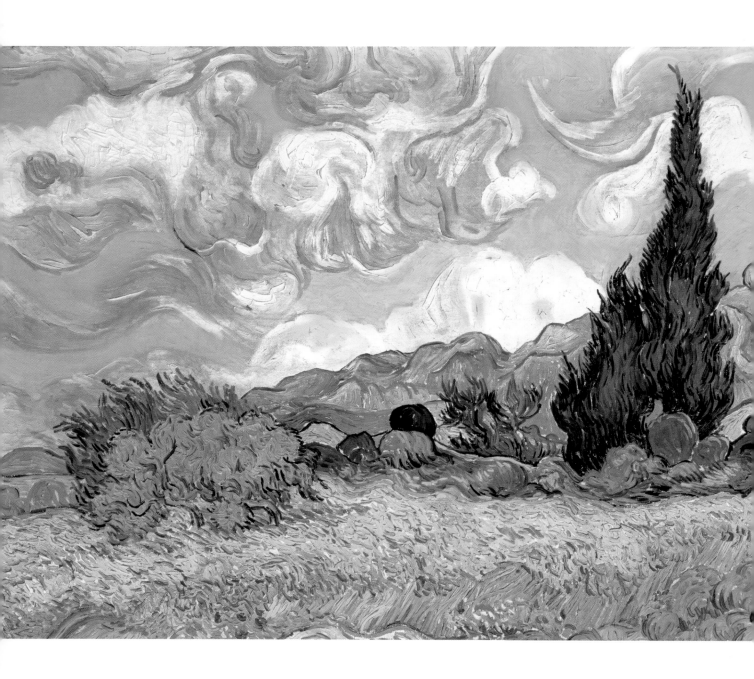

Wheatfield with Cypresses, 1889
Oil on canvas, 72.1 x 90.9 cm (28⅓ x 35¾ in)
• National Gallery, London

Another bold, calligraphic and expressive image, and one of his most recognizable pieces, Van Gogh's cypress trees have become symbolic of his lonely anguish towards the end of his life.

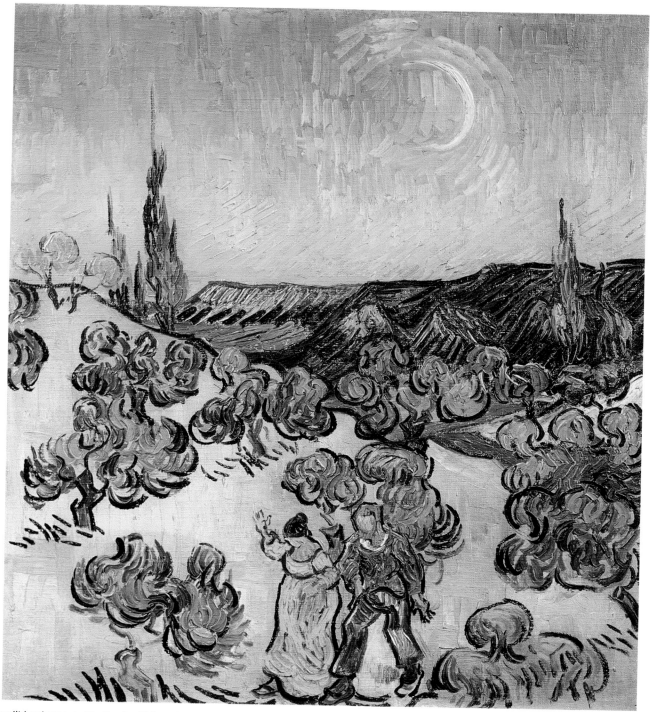

Moonlit Landscape, or, The Evening Walk, or, Landscape with Couple Walking and Crescent Moon, 1889–90
Oil on canvas, 49.5 x 45.5 cm (19½ x 18 in)
• Museu de Arte São Paulo, São Paulo

Distant buildings and trees loom darkly in the background of a Japanese-inspired landscape where two figures appear to be having a quarrel. The painting is demonstrative of the state of Van Gogh's health at the time.

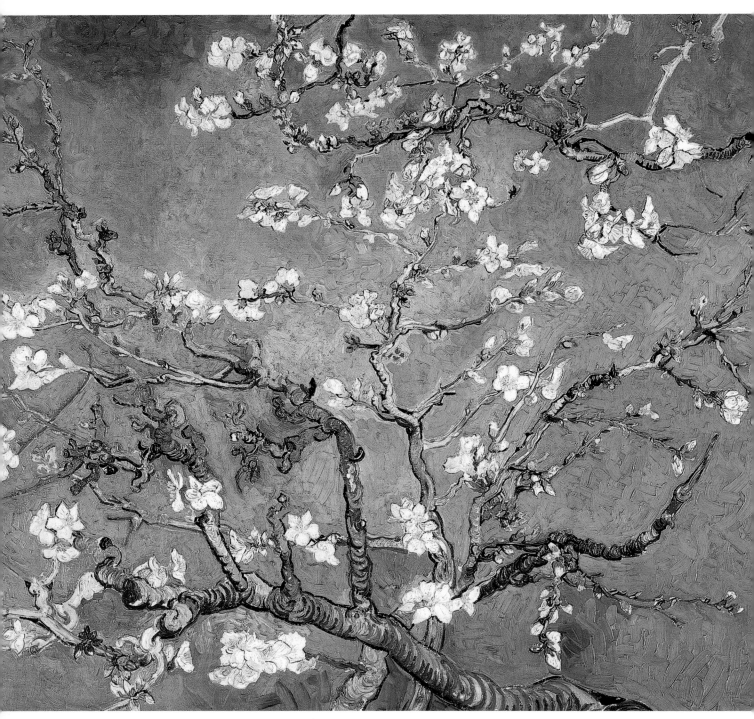

Almond Blossom, 1890 (detail)
Oil on canvas, 73.5 x 92 cm (29 x 36¼ in)
• Van Gogh Museum, Amsterdam

Painted as a gift to Theo on the birth of his son, the early blossom portrayed in this painting can be seen to represent new life and, in its unusual composition, reveals the influence of Japanese prints.

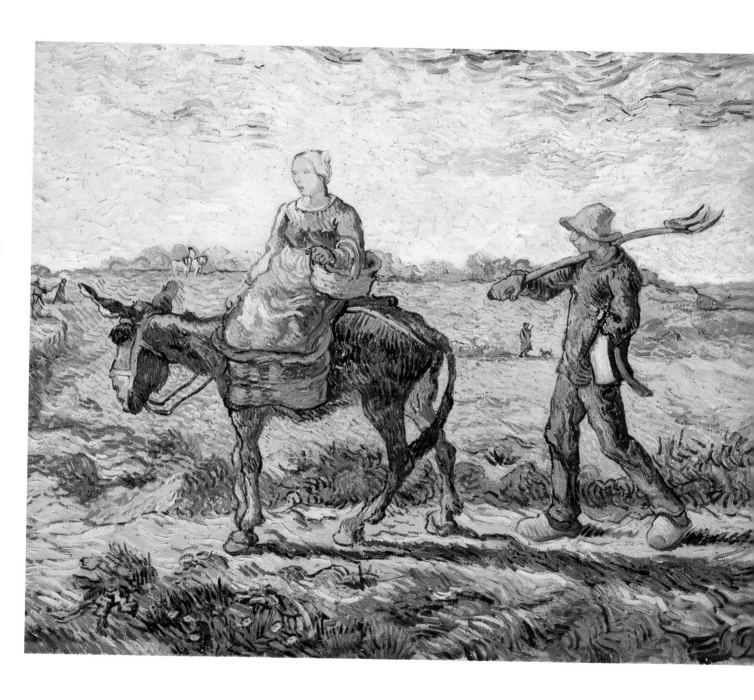

Morning: Going out to Work (After Millet), 1890
Oil on canvas, 73 x 92 cm (28¾ x 36 in)
• The State Hermitage Museum, St Petersburg

Influenced strongly by the peasant paintings of Jean-François Millet (1814–75), Van Gogh often translated them into his own style. His undulating brushstrokes and bold marks are markedly different from Millet's softly rendered images.

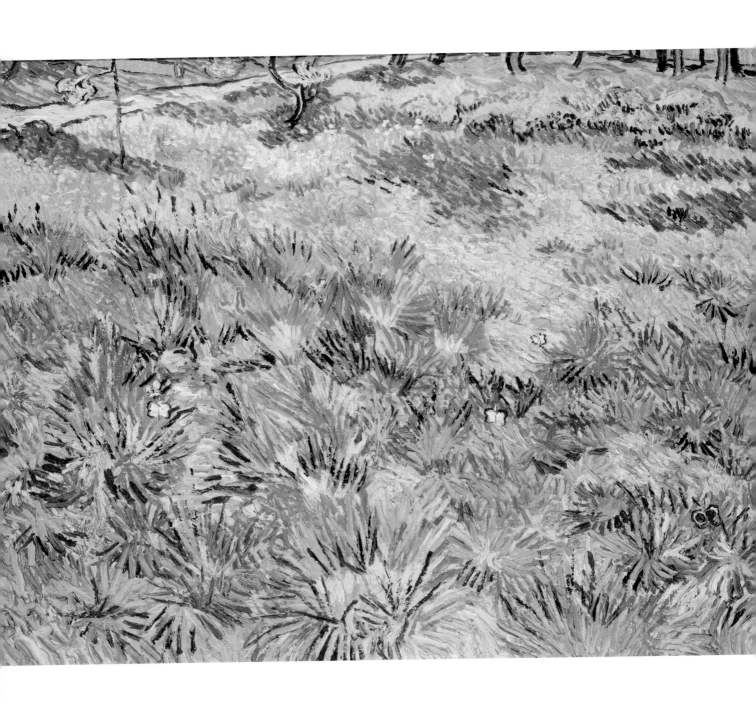

Long Grass with Butterflies, 1890
Oil on canvas, 64.5 x 80.7 cm (25¼ x 31¾ in)
• The National Gallery, London

Soon after his arrival at Saint-Rémy, Van Gogh described the 'abandoned gardens' of the asylum, in which 'the grass grows tall and unkempt, mixed with all kinds of weeds'. He painted this at the end of his stay.

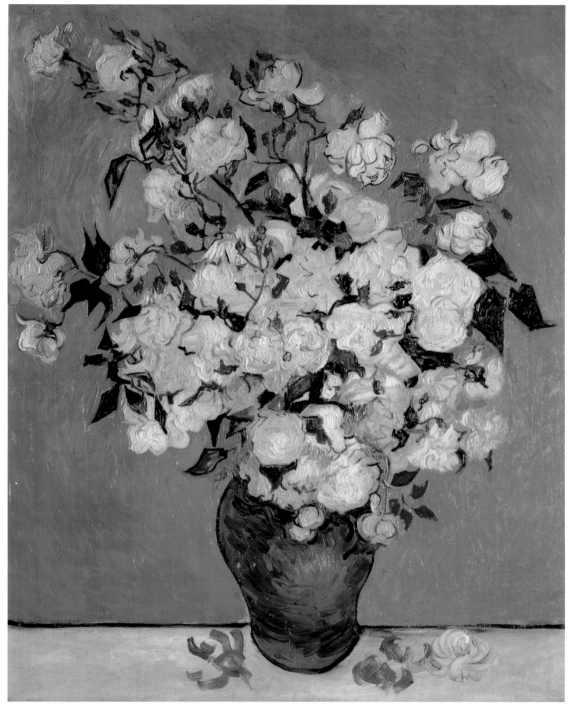

Roses, 1890
Oil on canvas, 93 x 74 cm (36⅝ x 29⅛ in)
• Metropolitan Museum of Art, New York

Just before he left Saint-Rémy in May 1890, Van Gogh painted four arrangements of flowers. His colours are soft, modest and delicate, with harmonies of pinks, greens, white and blue, recalling the decorative style of Japanese prints.

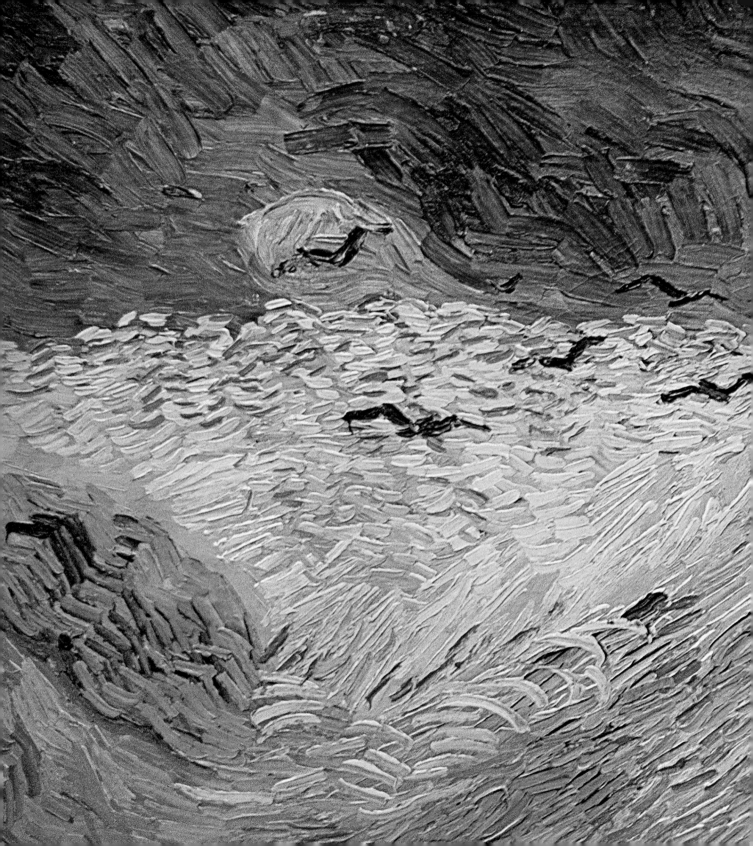

Auvers

In May 1890, Van Gogh moved to Auvers-sur-Oise to be treated by Dr Gachet. He painted prolifically, with colourful, expressive works, until his mood suddenly plummeted. On 27 July 1890, aged 37, he committed suicide.

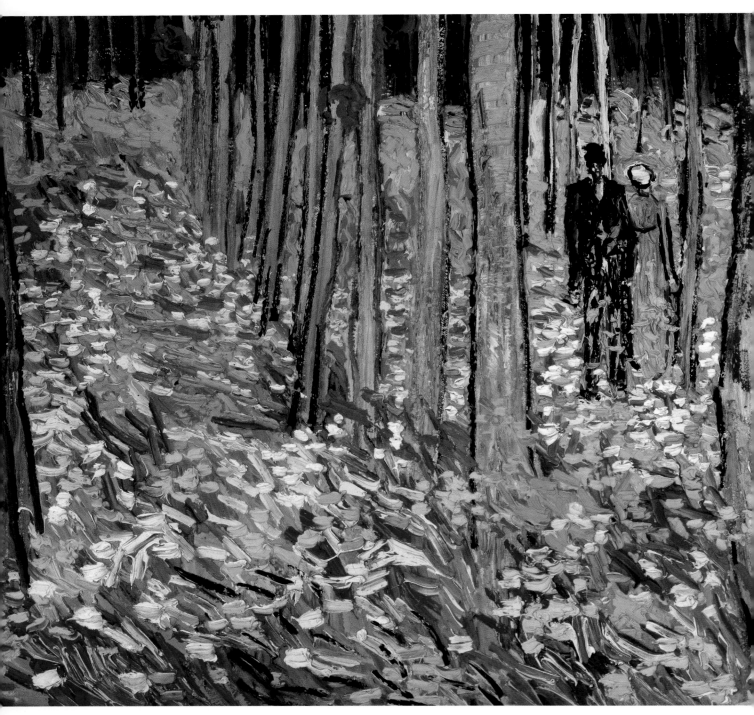

Undergrowth with Two Figures, 1890 (detail)
Oil on canvas, 49.5 x 99.7 cm (19½ x 39¼ in)
• Cincinnati Art Museum, Cincinnati

Looking between and beyond tree trunks was a theme that Van Gogh often explored. Two lovers are strolling in the wood. For Van Gogh, they embody the bond of companionship – something he sought all his life.

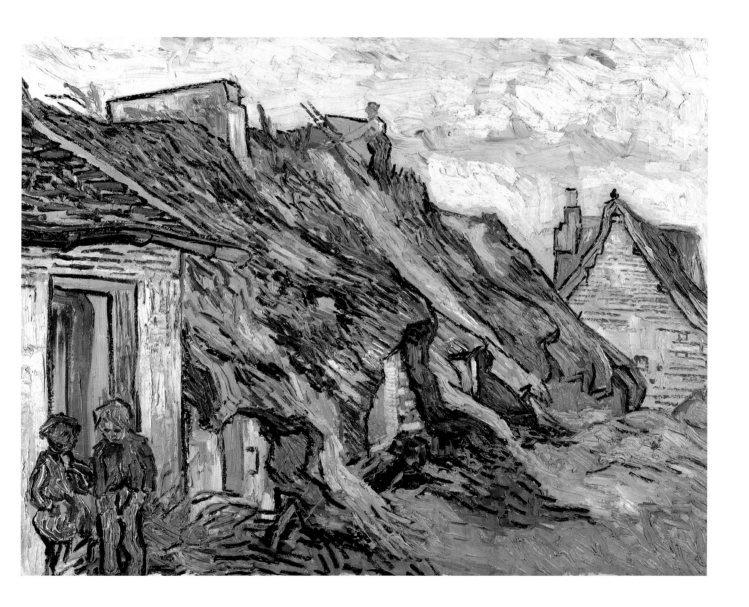

**Thatched Sandstone Cottages in Chaponval,
Auvers-sur-Oise, 1890**
Oil on canvas, 65 x 81 cm (25½ x 31¾ in) • Kunsthaus, Zurich

In the last letter he sent to Theo, Van Gogh sketched out the composition of this painting. Dramatic diagonals and expressive lines dominate, almost overpowering the workman on the roof and the two children.

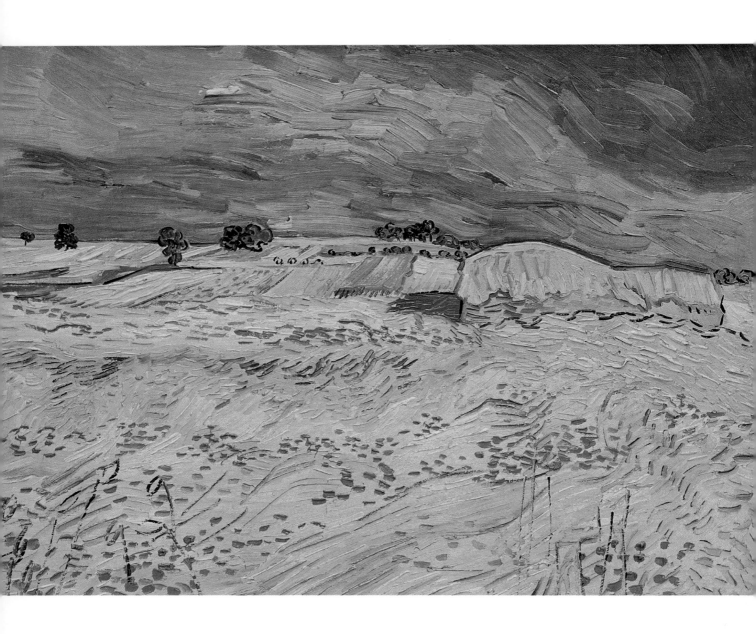

Plain at Auvers, 1890
Oil on canvas, 50 x 65 cm (19⅔ x 25½ in)
• Private Collection

Soon after Van Gogh had settled in the small country town of Auvers-sur-Oise, north-west of Paris, he began painting the scenery around him. Treating painting as therapy, he completed approximately one painting a day during this time.

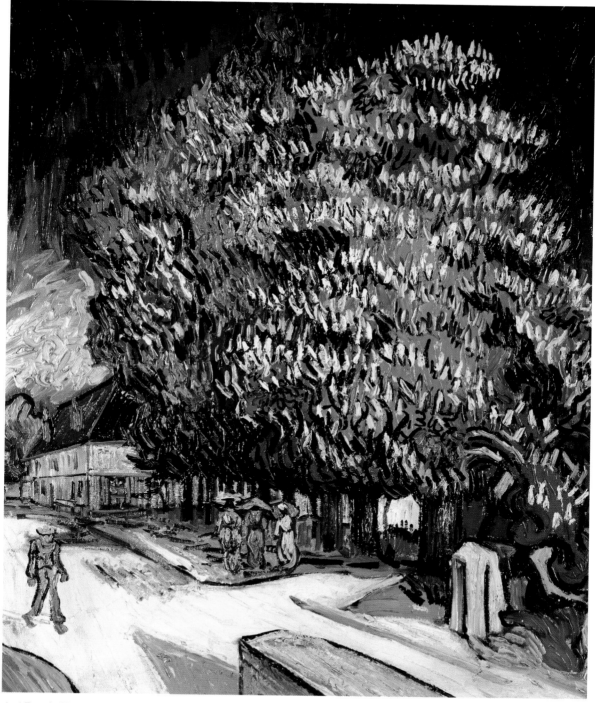

Chestnut Trees in Blossom, Auvers-sur-Oise, 1890
Oil on canvas, 70 x 58 cm (27½ x 22⅞ in)
• Private Collection

Painted in May 1890 when Van Gogh first arrived in Auvers, while the chestnut trees were still in bloom, this bold work demonstrates the hope and optimism he felt for the future, with no trace of his later despondency.

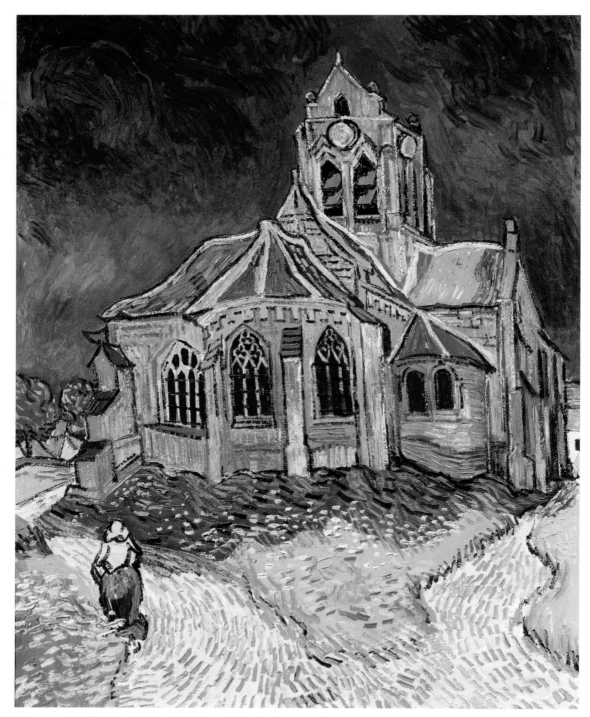

The Church at Auvers-sur-Oise, View from the Chevet, 1890
Oil on canvas, 94 x 74 cm (37 x 29 in)
• Musée d'Orsay, Paris

Settling in Auvers, Van Gogh plunged into painting. Built in the early Gothic style and flanked by two Romanesque chapels, he depicted the local church in bold and luscious colours from a low viewpoint with undulating contours.

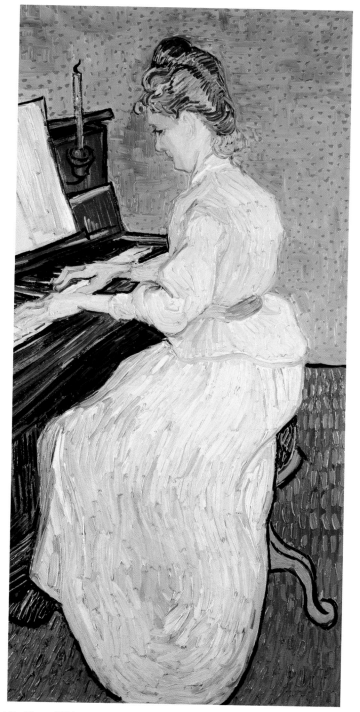

Marguerite Gachet at the Piano, 1890
Oil on canvas, 102.5 x 50 cm (40½ x 19⅝ in)
• Öffentliche Kunstsammlung, Basel

This is the nineteen-year old daughter of Dr Gachet, Van Gogh's doctor and friend in Auvers. To capture the mood of the moment, Van Gogh applied long brushstrokes for the piano, short dabs on the wall, and thick marks for Marguerite's dress.

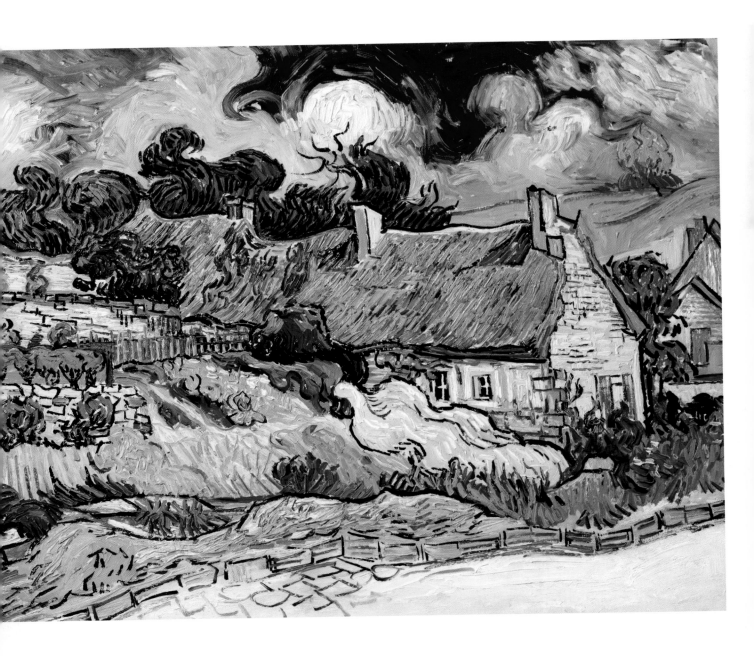

Thatched Cottages at Cordeville, Auvers-sur-Oise, 1890
Oil on canvas, 73 x 92 cm (28¾ x 36 in)
• Musée d'Orsay, Paris

In the summer of 1890, Van Gogh wrote to Theo that he was: 'Doing two studies of houses out in the countryside.' His impasto paint and undulating lines effectively create the impression that everything is moving.

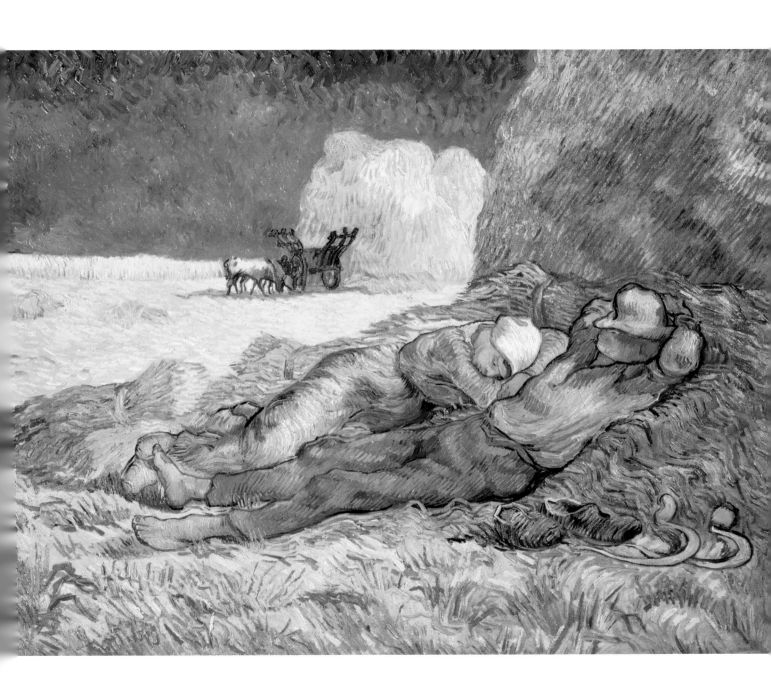

**Noon, Rest from Work (after Millet),
or, The Siesta (after Millet), 1890**
Oil on canvas, 73 x 91 cm (28¾ x 35¾ in)
• Musée d'Orsay, Paris

Inspired by one of Millet's drawings, Van Gogh's complementary colours create a striking effect. Two thirds of the painting is taken up with yellow-gold hay, contrasting with the blues of the sky and the peasants' clothing.

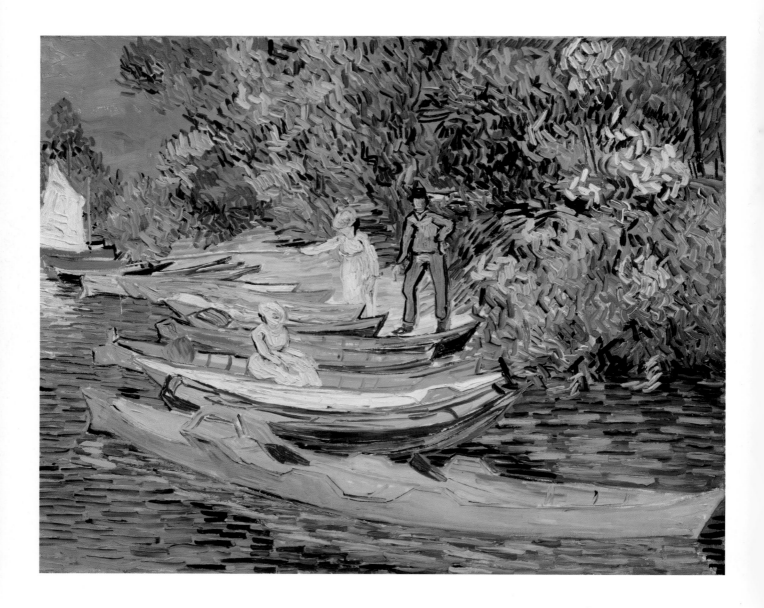

Bank of the Oise at Auvers, 1890
Oil on canvas, 73.4 x 93.7 cm (28⅞ x 36⅞ in)
• Detroit Institute of Arts, Detroit

A line of small boats are moored on the River Oise. A woman sits in one boat, while a man and woman are about to embark on another. Van Gogh's rapid brushmarks make the boats and trees appear to move in the breeze.

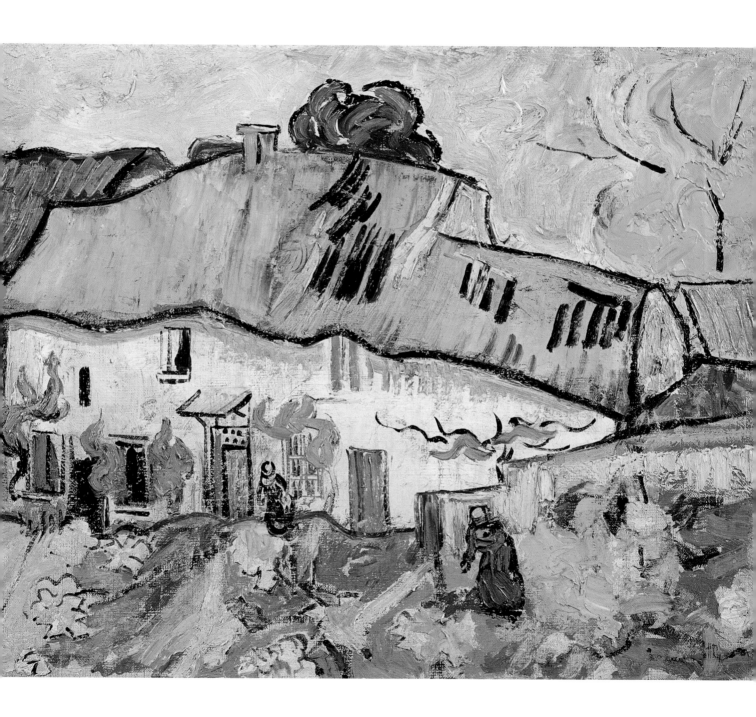

Farmhouse with Two Figures, 1890
Oil on canvas, 38 x 45 cm (15 x 17¾ in)
• Rijksmuseum Museum, Amsterdam

In Auvers, Van Gogh wasted no time in capturing the atmosphere with this expressive image. He wrote to Theo: 'Auvers is really beautiful – among other things many old thatched roofs, which are becoming rare.'

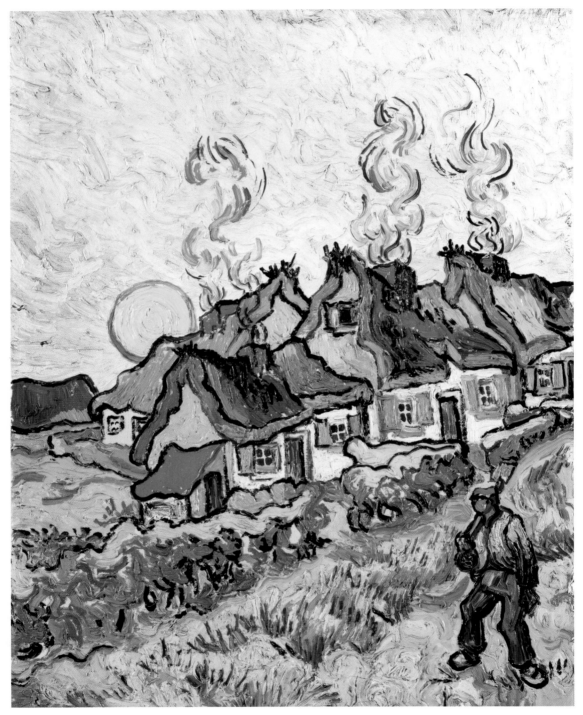

Houses and Figure, 1890
Oil on canvas, 52 x 40.5 cm (20½ x 15 in)
• The Barnes Foundation, Philadelphia

The thatched cottages of Auvers reminded Van Gogh of his native Brabant and he painted several versions of them. Without sentimentality, however, the vivid colours and curving brushstrokes express his renewed creative energy.

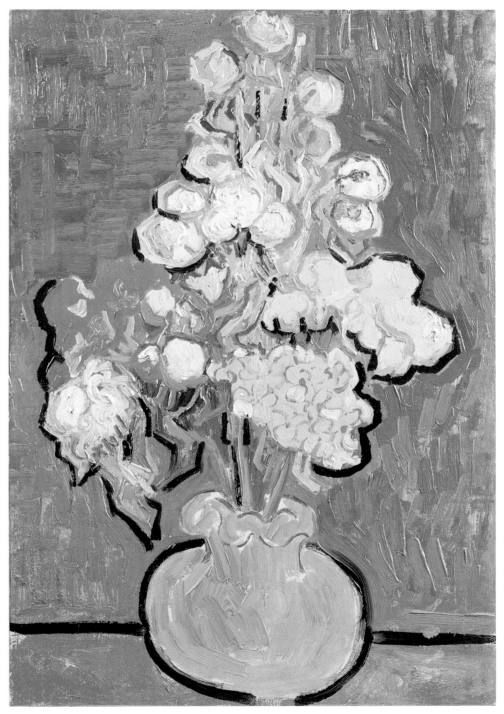

Bouquet of Flowers, or, Vase with Rose Mallows, 1890
Oil on canvas, 42 x 29 cm (16½ x 11½ in)
• Van Gogh Museum, Amsterdam

With impasto paint applied heavily and minimal sweeping marks, the speed with which Van Gogh worked is apparent here. Yet the work is also carefully planned; he knew what colours and shapes he wanted – and where.

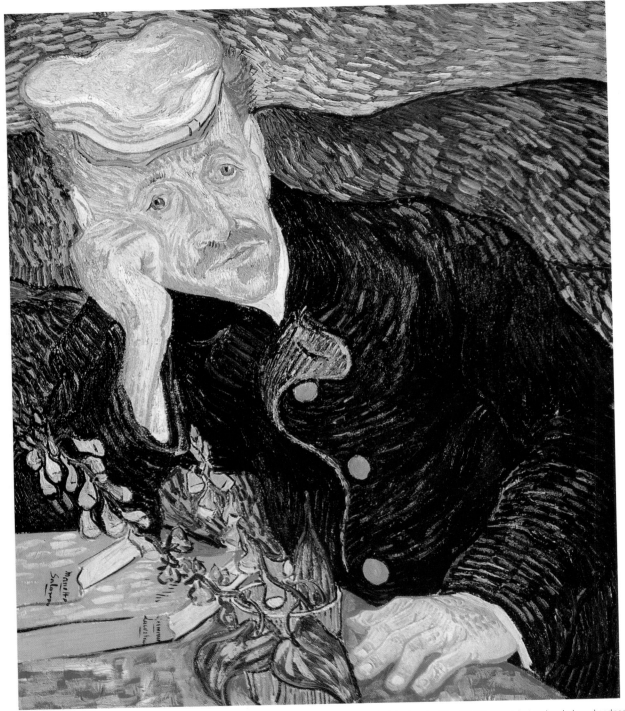

Portrait of Dr Gachet, 1890
Oil on canvas, 67 x 56 cm (26¼ x 22 in)
• Private Collection

Dr Paul Gachet was meant to be helping to raise his patient's spirits, but melancholy and sadness is apparent in his face. The two men became close friends, but Gachet's effectiveness in helping Van Gogh remains debatable.

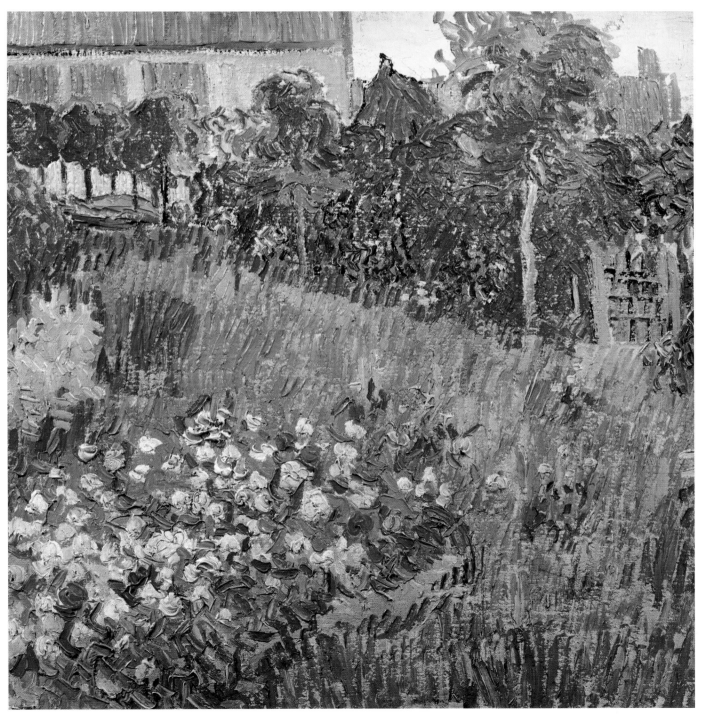

Daubigny's Garden, 1890
Oil on canvas, 50.7 x 50.7 cm (20 x 20 in)
• Van Gogh Museum, Amsterdam

All his life, Van Gogh admired the French landscape artist Charles-François Daubigny, who had died in Auvers in 1878. So when he arrived in Auvers from Arles, he obtained permission from Daubigny's widow to paint the garden.

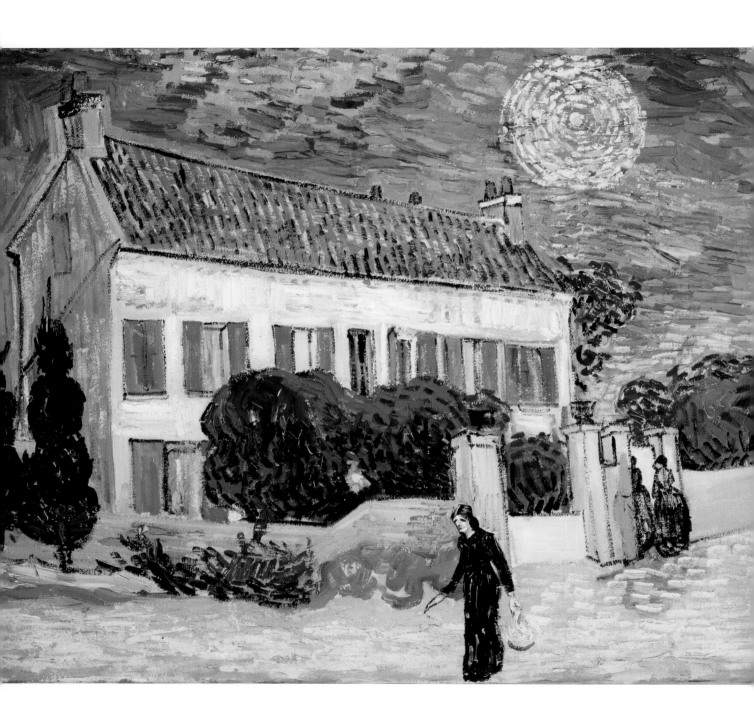

White House at Night, 1890
Oil on canvas, 59 x 72.5 cm (23¼ x 28½ in)
• The State Hermitage Museum, St Petersburg

When he moved to Auvers in May 1890, Van Gogh felt optimistic about recovering his health. He painted this in June when his emotions were beginning to fluctuate. The somewhat rigid composition reflects his psychological tension.

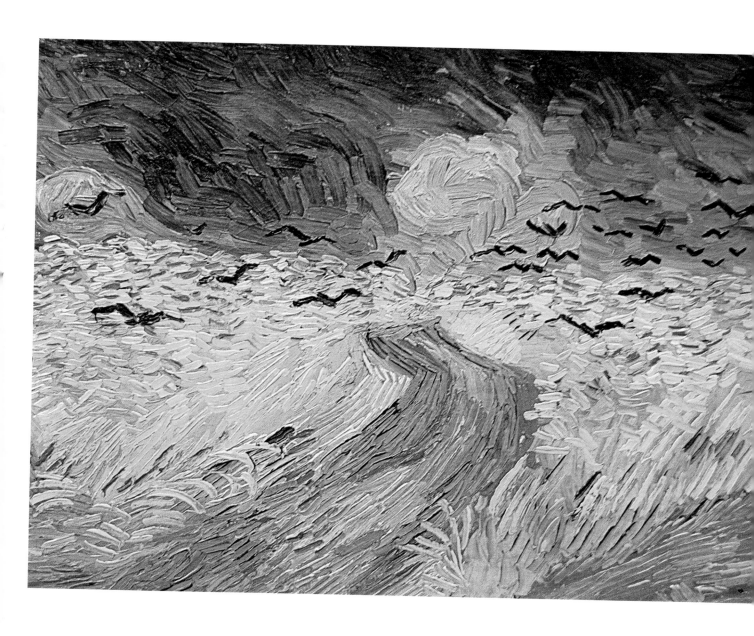

Wheatfield with Crows, 1890 (detail)
Oil on canvas, 50.5 x 103 cm (20 x 40½ in)
• Van Gogh Museum, Amsterdam

Echoing Van Gogh's 'sadness and extreme loneliness', the turbulent, stormy sky and gathering crows of this painting express his unsettling sense of foreboding. He wrote to Theo: 'My life … is attacked at the very root.'

Indexes

Index of Works

Page numbers in *italics* refer to
illustration captions.

A

Agostina Segatori in Le Tambourin
(1887) *43*
Almond Blossom (1890) *104*
Arlesienne, L' (Madame Joseph-Michel
Ginoux) (1888–89) *77*

B

Bank of the Oise at Auvers (1890) 27, *118*
Berceuse, La (1889) *83*
Bouquet of Flowers, or, Vase with Rose
Mallows (1890) *121*
Bridge at Trinquetaille, The (1888) *75*

C

Café Terrace on the Place du Forum,
Arles, at Night (1888) 26, 31, 32, *74*
Chestnut Trees in Blossom, Auvers-sur-
Oise (1890) 27, *113*
Church at Auvers-sur-Oise, View from the
Chevet (1890) *114*

D

Daubigny's Garden (1890) 13, *123*

E

Enclosed Field with Rising Sun (1889) *96*
Entrance to the Public Park, Arles
(1888) *73*

F

Farmhouse with Two Figures (1890) *119*
Farmhouses at Saintes-Maries (1888) *53*
Field with Poppies (1889) *98*
Fishing in Spring, Pont de Clichy
(Asnières) (1887) 32, *45*

G

Garden at Arles, or, Flowering Garden
with Path (1888) *56*
Garden of St Paul's Hospital, The 27

H

Half Figure of an Angel (after Rembrandt)
(1889) 8, *89*
Head of a Peasant Woman 30
Houses and Figure (1890) *120*

I

Imperial Fritillaries in a Copper Vase
(1887) *41*
In the Public Gardens in Arles (1888) *52*
Irises (1889) 15, 21, *93*
Italienne, L' (1887) *44*

L

Landscape with a Church and Houses 23
Long Grass with Butterflies (1890) *106*
Lover, Portrait of Paul-Eugène Milliet 31

M

Marguerite Gachet at the Piano (1890)
28, *115*
Memories of the Garden at Etten (Ladies
of Arles) (1888) *62*
Moonlit Landscape, or, The Evening Walk,
or, Landscape with Couple Walking and
Crescent Moon (1889–90) *103*
Morning: Going out to Work (After Millet)
(1890) *105*
Moulin de la Galette, Le (1886) *38*
Mousmé, La (1888) *55*
Mulberry Tree (1889) *97*

N

Night Café, The (1888) 31–32, *57*
Noon, Rest from Work (after Millet), or,
The Siesta (after Millet) (1890) *117*

O

Olive Grove (1889) *91*
Orchard in Blossom (Plum Trees)
(1888) *71*

P

Peach Trees in Blossom, or, The Plain of
La Crau with an Orchard (1889) *84*

Pietà (1889) *88*
Plain at Auvers (1890) 27, *112*
Poet, The, Portrait of Eugene Boch
21, 31
Pollarded Willows at Sunset (1888) *69*
Portrait of a Peasant (Patience Escalier)
(1888) 20, *65*
Portrait of Dr Felix Rey (1889) *92*
Portrait of Dr Gachet (1890) *122*
Portrait of Père Tanguy (1887–88) *49*
Portrait of the Postman Joseph Roulin
(1889) 20, *85*
Portrait of Trabuc, Attendant in St Paul's
Hospital (1889) *100*
Potato Eaters (1885) 16, 17–18, 30, *37*

Q

Quay with Men Unloading Sand Barges
(1888) *63*

R

Ravine, The (Les Peiroulets) (1889) *99*
Red Vineyard in Arles (1888) 22, *59*
Road Menders, The (1889) *101*
Roses (1890) 28, *107*

S

Schoolboy, The (Camille Roulin)
(1888) *76*
Seascape at Saintes-Maries (View of the
Mediterranean) (1888) *72*
Self Portrait (1889) 33, *94*
Self Portrait as a Painter (1888) 19, *61*
Self Portrait with a Bandaged Ear (1889)
12, *81*
Self Portrait with Straw Hat (1887) 19, *48*
Sower with Setting Sun (1888)
30–31, *68*
Starry Night over the Rhone, or, Starry
Night (1888) 21, *58*
Starry Night, The (1889) 12, 32–33, *90*
State Lottery, The 30
Still Life with Quinces, or, Still Life with
Pears (1888) *66*
Sunflowers (1887) *42*

T

Terrace in the Luxembourg Garden
(1886) 30
Thatched Cottages at Cordeville, Auvers-
sur-Oise (1890) *116*
Thatched Sandstone Cottages in
Chaponval, Auvers-sur-Oise (1890) *111*
Three Pairs of Shoes (1886–87) *40*
Trinquetaille Bridge, The (1888) *70*

U

Undergrowth with Two Figures (1890)
19, *110*

V

Van Gogh's Bedroom at Arles, or, The
Bedroom (1889) 21, 26, 30, 31, *79*
Van Gogh's Chair (1888) 18, *60*
Vase with Fifteen Sunflowers (1889)
15, *82*
Vase with Gladioli and China Asters
(1886) *39*
View of Arles (1889) *80*
View of Paris from Theo's Apartment in
the Rue Lupic (1887) 25

W

Wheatfield with a Lark (1887) *46–47*
Wheatfield with a Reaper (1889) 18, *78*
Wheatfield with Crows (1890) 13, *125*
Wheatfield with Cypresses (1889) *102*
Wheatfield with Sheaves (1888) *64*
White House at Night (1890) 14, *124*
Women Picking Olives (1889) *95*

Y

Yellow House, Arles (1888) 26, 30, 31, *54*
Young Man with a Cap (Armand Roulin)
(1888) *67*
Young Peasant Girl in a Straw Hat Sitting
in a Wheatfield, The 28
Young Scheveningen Woman Knitting
(1881) *36*

Z

Zouave 20

General Index

A
Alpilles 27
Antwerp Academy 16, 18, 20
Arles 11, 12, 18, 19, 20, 21, 22, 26, 33
 Yellow House, Place Lamartine 26, 27
Asnières, Paris 25
Aurier, Albert 15, 22
Auvers-sur-Oise 14, 27–28

B
Barbizon School 8
Bargue, Charles 29
Belgium 6, 21
Bernard, Émile 8, 9, 14–15, 17, 19, 21, 25
biblical references 8
Bing, Siegfried 25
Boch, Eugène 20–21
Borinage, Belgium 7, 21
Boussod, Valadon & Cie, Paris 25
brushwork 32–33
Brussels 7, 21, 22

C
Café De La Gare, Arles 31
café life 18
Catholicism 8
Cézanne, Paul 22
chiaroscuro 8
Christie's, London 15
colour 29, 33
 dark palette 30
 Japanese influences 30–31
 light palette 30
 perspective 31–32
 The Night Café 31–32
Constable, John 24
Cormon, Fernand 17
Correggio, Antonio 24
cypresses 18, 19, 33

D
Daubigny, Charles-François 13
Daumier, Honoré 8
Delacroix, Eugène 24, 25
Dickens, Charles 18, 24
Dordrecht, Netherlands 7
Douglas, Kirk 11
drawings 29
Drenthe, Netherlands 23
Dutch art 8, 18, 23

E
ear, self-mutilation of 11–12
education, Van Gogh's 16–17
École des Beaux-Arts, Paris 16–17
Eliot, George 24

English art 9, 24
English literature 7, 18, 24
engravings 9
epilepsy 11, 12
Espace, Arles 26
Etten, Gelderland 10, 23
exhibitions 21, 22, 24
Expressionists 22

F
Fauves 22
French art 7, 18, 22
French literature 7

G
Gachet, Paul 27
Gainsborough, Thomas 24
Gauguin, Paul 6, 9, 11, 17, 19, 21, 22, 25, 26, 27
German art 22
Goupil & Cie Gallery, Hague 7, 8, 23
 London 23
 Paris 24, 25
Grand Bouillon Restaurant du Chalet 21
Graphic 9, 24
Groot Zundert, North Brabant 6, 23
Groux, Henry de 22

H
Hague 7, 10, 23, 24
Hague School 8, 16, 33
Hals, Frans 20
Harpers 24
haystacks 18
Holland *see* Netherlands
homeopathy 27
Hoornik, Clasina 'Sien' 10
Hugo, Victor 24

I
Illustrated London News 9, 24
impasto brushwork 32–33
Impressionists 16, 17, 25, 27, 28, 29
 influence on Van Gogh 25, 30
Industrial Revolution 16
influences
 on Van Gogh 7–8, 18–19, 33
 on other artists 22
insanity and mental illness 6, 11, 12, 27
Israëls, Jozef 8

J
Japanese prints 12, 16, 18, 21, 25, 30–31

L
landscapes 18, 21, 27
letters 9
Livens, Horace Mann 16, 17

London 7, 9, 23–24, 29
Louvre, Paris 25
Loyer, Eugenie 24
Loyer, Ursula 24
Lust for Life 11

M
Maris, Jacob 8
Mauve, Anton 16
Mercure de France 22
Michelet, Jules 24
middle classes 16
Millais, John Everett 24
Millet, Jean-François 8, 16
Minelli, Vincente 11
miners 7, 21
Monet, Claude 29
Montmartre, Paris 25

N
Nabis 22
Neo-Impressionists 17
Netherlands 6, 23
Nuenen, North Brabant 17, 20, 23

O
olive trees 18, 19
outdoor working 28–29

P
painting therapy 27
palette 29–31
Paris 11, 12, 13, 15, 14, 16, 17, 18, 19, 20, 21, 23, 24–26, 29
peasants 8, 16, 17–18, 28
perspective 25, 29, 31
Peyron, Théophile 12
Pissarro, Camille 27
pointillism 32
portraits 18, 20, 27, 28, 31
Post-Impressionists 18, 28
Pre-Raphaelite Brotherhood 24
preaching 6, 7, 24
Provence 29
psychosis 6, 11, 12, 27
Punch 24

Q
Quinn, Anthony 11

R
Ravoux Inn, Auvers-sur-Oise 14
Realism 8, 23, 24, 33
religion 6, 7, 9, 24, 26
Rembrandt Harmenszoon van Rijn 8, 24
Renoir, Pierre Auguste 22
Reynolds, Joshua 24

Royal Academy 24
Rubens, Peter Paul 16

S
Saintes-Maries-de-la-Mer 26
Saint-Paul-de-Mausole, Saint-Rémy 12, 27
Saint-Rémy-de-Provence 12, 19, 21, 27, 33
Salon 7, 21, 22
Salon des Indépendants, Paris 13, 15, 21
self-portraits 19, 25, 33
Seurat, Georges 17, 32
Shakespeare, William 24
Signac, Paul 17
Sisley, Alfred 22
Société des Artistes Indépendants 21
society 16
Sotheby's, London 15
Sower series 18
still life 18
suicide 13, 14
Sunflowers series 11, 21
Symbolistes 22

T
Tambourin Café 21
Tanguy, Père 25
teaching 7, 24
Toulouse-Lautrec, Henri 17, 21, 22, 25
trees 18, 19, 29
Turner, J.M.W. 24

V
Van Gogh Museum 15
Van Gogh-Bonger, Johanna 9
Van Gogh, Theo 6, 7, 9, 10, 12, 16, 18, 19, 20, 21, 24, 25, 26, 29, 31, 33
 death 14
 financial support 14, 26
Van Gogh, Theodorus 6
Van Rappard, Anthon 9, 18, 20
Velázquez 8
Vermeer, Johannes 8
Vincent Van Gogh Foundation 15
Vingt, Les 21, 22
Vos-Stricker, Kee 10

W
Weissenbruch, John Hendrik 8
wheat fields 13, 18, 28, 33
working classes 7, 16, 17, 19
World's Fair 1867, Paris 18

Y
Yellow House, Place Lamartine 26, 27

Z
Zola, Emile 7
Zundert, North Brabant 6, 23

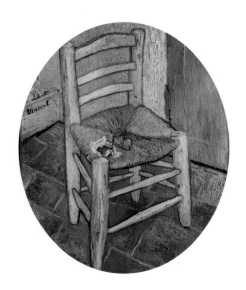

Masterpieces of Art

FLAME TREE PUBLISHING

A new series of carefully curated print and digital books covering the world's greatest art, artists and art movements.

If you enjoyed this book, please sign up for updates, information and offers on further titles in this series at

blog.flametreepublishing.com/art-of-fine-gifts/